SECRET LUTON

Paul Adams

AMBERLEY

For Bev Creagh

First published 2017

Amberley Publishing
The Hill, Stroud
Gloucestershire, GL5 4EP

www.amberley-books.com

Copyright © Paul Adams, 2017

The right of Paul Adams to be identified as the
Author of this work has been asserted in accordance
with the Copyrights, Designs and Patents Act 1988.

ISBN 978 1 4456 6632 7 (print)
ISBN 978 1 4456 6633 4 (ebook)

British Library Cataloguing in Publication Data.
A catalogue record for this book is available from the
British Library.

Origination by Amberley Publishing.
Printed in Great Britain.

Contents

Acknowledgements

I would like to thank the following people who have helped in providing information and illustrations for this book: Steve Spon, Eddie Brazil, Leah Mistry, Ben O'Dell and the Old Photos of Luton Facebook Group, Jane Santana, Martin Deacon, Steve John, Nick Catford, Wayne Kinsey, Alessandra Vinciguerra, Tony Scotland, Revd Steve Wood, Jacqui Blake, Richard Clark, Sally Jones, Ron Asupool, Chris Warren, Richard Horn, Carolyn Shirley, Catherine Casamian, Sarah Angleitner, Howard Chandler and Linda Tucker.

Every effort has been made to trace and contact copyright holders of photographs and illustrations used in this book. The publishers will be pleased to correct any mistakes or omissions in future editions. All photographs are presented here for educational purposes only and should not be reproduced.

By the same author:
The Borley Rectory Companion
Shadows in the Nave
Extreme Hauntings
Haunted Luton & Dunstable
Haunted St Albans
Haunted Stevenage
The Little Book of Ghosts
Ghosts & Gallows
The Enigma of Rosalie

Introduction

Luton is a town with a rich and varied history. It is also a town that has, to its great advantage, had this history set down and examined in considerable detail over the course of many years. In recent times the diverse source of local knowledge known to many Lutonians who have grown up and lived here has, thankfully, been preserved for posterity in several specialist books that have covered a wealth of home-grown subjects from dance bands to shopkeepers and choral singing to pubs.

Why then does Luton need another history book? In *Secret Luton* I have attempted to answer this question by setting down what is hopefully an interesting mixture of facts and accounts that are decidedly off the beaten track where previous collections are concerned. Although some general history is included to set the scene, I have tried where possible not to revisit the work of previous writers and historians. This is why instead of the Hatters and Luton Airport you will find a connection to a famous wartime witchcraft trial, and will read about how Vauxhall cars made way for one of the great unsung heroes of the British film industry. Lace and hat making are also either conspicuous by their absence or are only mentioned briefly in passing.

It goes without saying that if I have been able to investigate, discover and set down all of the various stories, histories and details that you are about to encounter, then

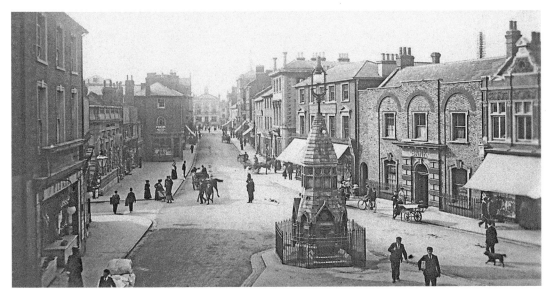

Looking along George Street in Victorian Luton with the old Town Hall in the distance. (Luton Culture)

undoubtedly other people will know about them as well. However, not everyone knows everything. I hope that by bringing *Secret Luton* together it will introduce an eclectic undercurrent of local history that will be of interest to Lutonians both young and old, and if every reader of this book says at some point 'Well, I never knew that,' then it will have served its purpose.

I hope you enjoy this book as much as I have done researching and writing it.

Paul Adams
Limbury, Luton, 2017

1. Ancient Luton

It is easy to assume, as we make our way through the noisy bustle of a busy Luton morning, that the town is an essentially modern entity. The continual replacement of the old with the new blurs the fact that the history of Luton goes back over a thousand years. If we dig deeper we will find that long before either the Celt Lugh founded his tun (or town) on the banks of the River Lea, or the ford belonging to the Saxon thane Bedda gave title to the county in which Luton lies, this area was travelled and settled by ancient man.

The earliest evidence for settlement in what would become present-day Luton has been found at Round Green and Mixes Hill in Stopsley. Here there were early Stone Age (Palaeolithic) encampments dating from around 250,000 years ago. Following the retreat of the glaciers after the last Ice Age, new settlements began to reappear during the Mesolithic (or Middle Stone Age) period around 8,000 BC in what is now Leagrave.

We will encounter Galley Hill several times during our look at secret Luton. Here there is evidence of Neolithic activity from the New Stone Age period of 4,500–2,500 BC.

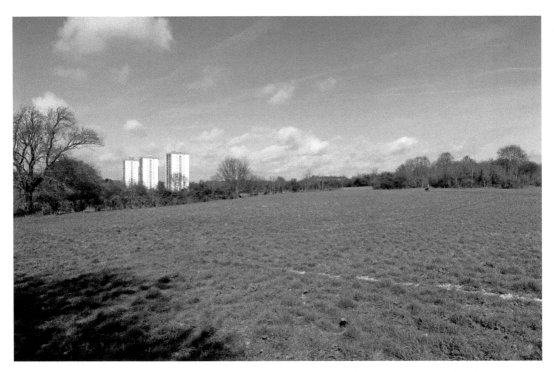

Ancient and modern: the interior of the Wauluds Bank henge with Marsh Farm tower blocks in the background. (Paul Adams)

Perhaps the most important Neolithic structure in Luton is Wauluds Bank, a henge dating from around 3,000 BC. The earthworks lie on the western edge of the Marsh Farm estate with the River Lea on its western side. Wauluds Bank Drive, which passes close by the henge, was named after it in 1967. Although archaeological excavations date the site to the Neolithic period, there is evidence of earlier Mesolithic activity in the surrounding area. From the New Stone Age onwards, the area that would become Luton seems to have become thickly populated but without any single large settlement or centre.

DID YOU KNOW?

The name of the River Lea can be interpreted in various ways from the Celtic language and is possibly named after the Celtic god Lugus. It flows for 42 miles from Luton into Hertfordshire and on through East London to join the Thames at Bow Creek, a tidal estuary that forms the boundary between the London boroughs of Newham and Tower Hamlets.

Now for a quick history lesson. The people of Middle Stone Age Britain were nomadic hunter-gatherers who foraged and hunted for food as they continued on their cyclical journey through the landscape. They were flint users, crafting axes, tools and spears. Part of their annual trekking would have taken them through the river tributaries and escarpments of the landscape that would become modern-day Bedfordshire. The introduction of agriculture in around 5,000 BC brought an end to this nomadic existence. Now they could grow crops and harvest the earth, but more importantly, they could settle and remain in their chosen location, establishing farms and communities.

By around 1,000 BC, Britain was to see a gradual influx of peoples. These newcomers would bring with them a common tongue, a shared Celtic heritage, and introduce advances in metalworking technology, which would give the epoch a new name. Iron Age Britain is thought to have lasted from around 800 BC to the arrival of the Romans in 55 BC. In that time the country had become settled by a patchwork of neighbouring Celtic tribes who continuously competed with each other for dominance and supremacy. Included among them were the Iceni, who controlled what is now modern-day Norfolk and Suffolk. On the south-east coast, the Canti held sway – from them the county of Kent takes its name. Up on the north-east coast, near modern-day Lincolnshire, was the territory of the Parisi. It is believed that one day they upped sticks and sailed down the North Sea, across the English Channel and along the River Seine to found the city which still bears their name: Paris.

In central-southern Britain, an area comprising Hertfordshire, Cambridgeshire, Buckinghamshire and Bedfordshire, including what would become Luton, was the territory ruled by the Catuvellauni. If you had been a resident in Luton or the surrounding area 2,000 years ago, you could have counted yourself as one of the Catuvellauni.

Pre-Roman Britain, showing Luton's location within the territory of the Catuvellauni tribe. (Eddie Brazil)

DID YOU KNOW?

The Catuvellauni were a fierce, Celtic-speaking, spiked or long-haired warrior race who painted their bodies in blue woad and charged into battle on foot, or mounted on armoured scythe-wheeled war chariots. Their original capital was based at Wheathampstead, just over 6 miles south-east of Luton.

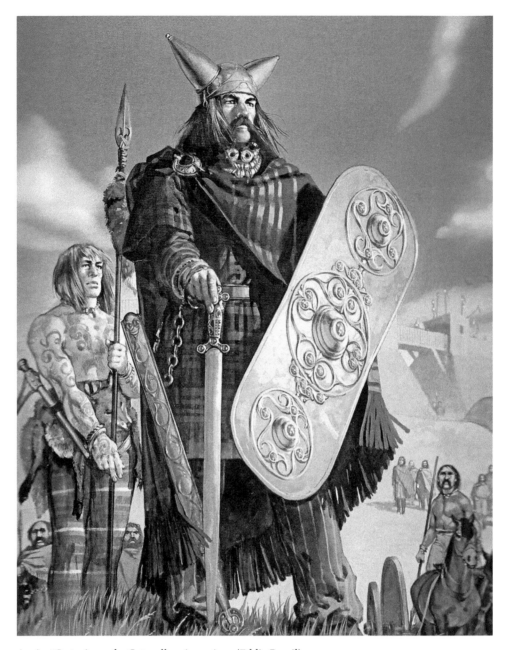

Ancient Lutonians: the Catuvellauni warriors. (Eddie Brazil)

The Catuvellauni would have used Wauluds Bank as a defensive structure when faced with attack by neighbouring tribes. The Iron Age hill fort at Maiden Bower in Houghton Regis would have been similarly used. At Hexton, 5 miles north of Luton town centre, is Ravensburgh Castle. Rectangular in shape and enclosing 9 hectares, it is strongly defended by a double rampart and ditch on the north, west and south sides, with a

massive rampart on the vulnerable eastern flank. It is believed it was once the stronghold of the Catuvellauni king, Cassivellaunas. Archaeological evidence suggests that the camp was attacked at some point during the Roman invasions of Britain, and it was possibly at Ravensburgh that the Celts fought their penultimate battle before their eventual defeat at their capital at Wheathamstead. Thereafter, Britain became part of the Roman Empire.

The Roman occupation of Britain lasted over 400 years. Those Celtic tribes who had refused to submit to the rule of Rome fled west to Cornwall and Wales, or across the sea to Brittany. For the peoples of ancient Luton, life must have continued much as it had done for centuries, as during the Roman period it remained a series of scattered farmsteads. The first urban settlement nearby was the small Roman town of Durocobrivis – modern-day Dunstable – where the legions created the road, possibly as a strategic measure, now known as Watling Street at its junction with the Icknield Way. Running from Norfolk to Wiltshire, this is considered to be one of the oldest continuous trackways in the country.

The signs of the Roman occupation of what would eventually become Luton is somewhat sparse. At Stockwood Park, evidence of a Roman road was discovered in the grounds of Farley Junior School in 1960, probably dating from AD 250–350. At Wigmore Valley Park, a possible Roman villa dating from AD 50–350 was unearthed during the laying of a water main, while in Park Street archaeologists monitoring building work discovered Roman pottery and tiles suggesting a building dating of AD 100–200. There is also evidence of a Roman settlement in Limbury.

The Romans would come to leave their most substantial footprint in the area closest to Luton at St Albans. Here one can still see the remains of the amphitheatre and the former

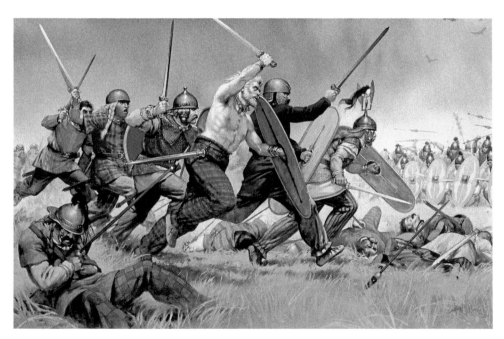

Last stand of the Catuvellauni: the final battle was fought at their capital in present-day Wheathampstead, a few miles from Luton. (Eddie Brazil)

city walls. But the clock was ticking for the victorious armies of Rome. Four centuries after their triumphant arrival, barbarian raids on the eternal city had forced the legions to return home. Britain was left to defend itself from invaders from Scandinavia and Germany. The English were coming.

The departure of the Romans in AD 450 left a power vacuum in Britain. Raiders from across the Irish Sea, and marauding Picts streaming across Hadrian's Wall, vied with one another to gain control of the old Roman province. Tradition has it that the Romano-British leader, Vortigen, called on the help of two Anglo-Saxon mercenaries, Hengist and Horsa, to aid him in his quest in holding back the invading forces. The Saxons duly put the Scots and Irish to flight, but then took a look around and saw what a beautiful, and more importantly rich, land Britannia was and decided to stay. Word was sent back to their kinsman across the North Sea and soon waves of Angels, Saxons and Jutes arrived on Britain's shore. The rest they say is history. A new nation, language and culture was born: 'Angle land'.

The foundation of Luton is usually dated to the sixth century when a Saxon outpost was founded on the River Lea – the *ton*, or town, on the River Lea. Although this is the usually quoted etymology, there is evidence to show that Luton is named after the Celtic god Lugus, pronounced 'loo'; the river was once called Lugh and the settlement Lugh's Town later becoming Luton.

The Anglo-Saxon invaders were attracted to Bedfordshire because of its abundant water supply and suitability for agriculture. Between AD 500–850, what would become England was divided into a series of seven separate kingdoms known as the Heptarchy. They included East Anglia, Mercia, Northumbria, Kent, Wessex, Essex and Sussex. Over the years, each would experience supremacy and subjugation. However, by the year AD 796, the kingdom of Mercia, or Middle Angles, which stretched from the River Humber in the north to the Tamar in the south-west, became the dominant force in England. The county of Bedfordshire would eventually emerge from the kingdom of Mercia.

In AD 571, the West Saxon chieftain Cuthwulf invaded Mercia and inflicted a severe defeat on the Romano-British at Bedford. It is also possible that he attacked Luton. If the Anglo-Saxons weren't fighting each other, they had to contend with the wrath of the Norsemen. Throughout the ninth century England was continuously raided by the Danes, and one by one the English kingdoms fell under the yolk of Viking power. The victorious Norsemen divided the country into Saxon England to the west and the Danelaw to the east, in a line running roughly north-east from London to Chester. Luton stood on the border between Christendom and heathenism, which ran up the River Lea from London through to Bedford. The people of Luton, however, were not going to take subjugation by the Danes lying down. The Anglo-Saxon Chronicle records in the year 913 a Viking raiding force attacked the town, but were soon seen off by the locals.

The English were to recover most of Bedfordshire during the reign of King Edward the Elder (899–924), the son of Alfred the Great. It was King Edward's son and heir, Athelstan, who was king of the Anglo-Saxons from 924 to 927 and king of the English from 927 to 939, who recovered all of England from the Danes. He is regarded as the first

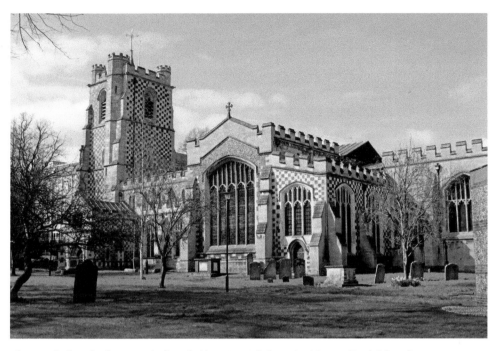

The parish church of St Mary's, founded by King Athelstan in AD 930. (Paul Adams)

king of England and one of the greatest Anglo-Saxon kings. It was Athelstan who founded Luton's parish church, St Mary's, in 930 as an act of thanksgiving for his victories over the Vikings.

The Danes, however, were to return. In 1016, King Cnut laid waste to Bedfordshire. He would become king of England and join the country to a Scandinavian empire. Despite future setbacks from further Danish attacks and invasion in 1066 by the Normans, the nation of England, the county of Bedfordshire and the little town on the River Lea, together with its language, people and culture, had been firmly established. All would withstand, absorb and supersede its ruling French-speaking aristocracy.

Now we fast forward over 900 years, from the Luton of a bygone age to that of a town within living memory and one that we know and live in today.

2. Musical Luton

Music, both the craft of music making and the enjoyment of listening to live performance, is one of the most underrated of Luton's activities. There is a long and distinguished history of musical activity in the town involving many fine visiting and homegrown musicians.

Vocal music has a long tradition in Luton. The Luton Choral Society was established in 1866. One of its founding members was Joseph Hawkes, who became the society's first conductor and helmed many early performances including a complete presentation of Haydn's oratorio, *The Creation*, in December 1871. For over thirty years beginning in 1899 the society was led by composer Frederick James Gostelow (1867–1942). Gostelow was born in Dunstable and was the organist and choirmaster at St Mary's Church. He oversaw

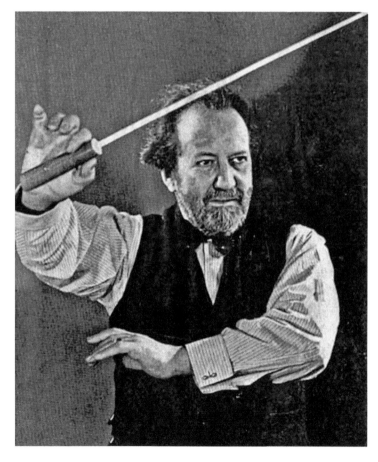

The noted English conductor Sir Henry Wood, who visited Luton to conduct the Luton Choral Society.

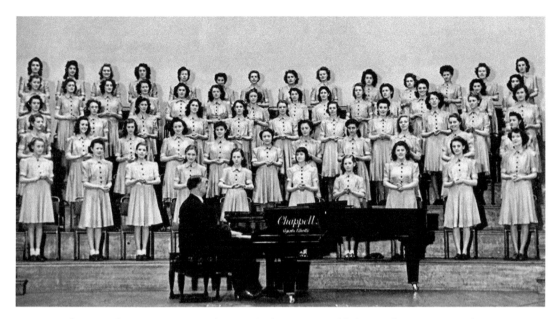

A performance by the Luton Girls' Choir (Malcolm Morris – Old Photos of Luton FB group)

the society's Golden and Diamond Jubilee seasons, and during his tenure many notable British composers and conductors were invited to perform their own compositions. They included the now neglected Sir Frederick Cowen (1852–1935), Sir Granville Bantock (1868–1946), and Sir Henry Wood (1869–1944), the founder of the celebrated London Proms.

Two other long-established choral groups with a rich history are the Luton Girls' Choir and the Vauxhall Male Voice Choir. Arthur Davies, by profession an agricultural agent, formed the Luton Girls' Choir in 1936. Within ten years, the Luton Girls were a highly regarded ensemble, as shown by their presence at the celebration concert given at St Paul's Cathedral in 1947 for the 80th birthday of Queen Mary. The following year they gave a Royal Command Performance and took part in the opening ceremony of the Summer Olympic Games at Wembley Stadium. Although the choir was an international one with trips abroad during the 1950s to Australia, New Zealand and Denmark, membership was kept wholly local. All choir members had to live within 5 miles of Luton Town Hall and were able to sing up until the age of twenty-three or the time they were married, whichever came first. Davies, who was awarded an MBE for services to music and was the subject of *This Is Your Life* in 1962, died in 1977. The choir's final performance was a tribute concert, 'Music you know and love', given in his memory on Saturday 5 November 1977 at St Mary's Church. Works performed included pieces by Puccini, Arthur Sullivan, Tchaikovsky, Saint Sans, and Rogers and Hammerstein. The conductor was the highly regarded Luton musician Colin Smith.

The Vauxhall Male Voice Choir was founded during Luton's war years in 1943. Other local industrial companies also had their own choirs including Electrolux and Skefco. George Flounders, a semi-professional baritone, together with musician Richard Atkinson,

Arthur Davies, the highly regarded founder of the Luton Girls' Choir. (Author's collection)

led the Vauxhall Choir in its early years. During the 1950s there were prize-winning performances at the Balham and Streatham Music Festival, as well an appearance at Wormwood Scrubs that almost created a riot during the opening piece, 'Stout-hearted Men', from Sigmund Romberg's 1927 operetta *The New Moon*.

DID YOU KNOW?

Nigel Kennedy, one of the most popular and recognisable violinists of the past thirty years, made his professional debut as a soloist with the Luton Symphony Orchestra. On 8 December 1984, Kennedy played the Mendelssohn Violin Concerto in a concert conducted by Colin Smith. Also on the programme that evening were works by Brahms, Dvorak, and Michael Marsh-Edwards, who was the orchestra's very first conductor when it was formed (initially as the Luton Youth Orchestra) in 1953. Other noted soloists who have played with the LSO over the years include clarinettist Jack Brymer (who recorded Richard Strauss' *En Heldenleben* in the presence of the composer) and pianist Malcolm Binns.

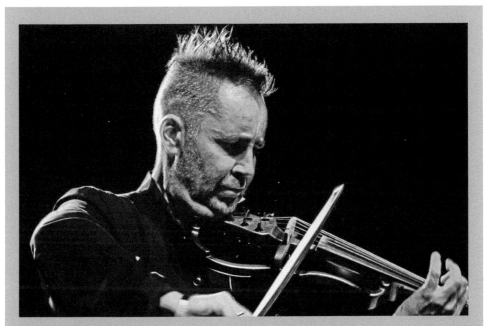

Violinist Nigel Kennedy, who made his professional concert debut with the Luton Symphony Orchestra in 1984. (Classic FM)

With the advent of rock 'n' roll and new styles of popular music in the 1950s, both Luton and Dunstable became a regular venue for new and soon-to-be established bands. In Dunstable, the California Ballroom (the 'Cali') quickly established itself on the music circuit after opening in March 1960. Later in 1966, the Civic (later Queensway) Hall added another venue of an audience capacity that despite its size as a town, Luton lacked. Both of these Dunstable venues have now disappeared – the 'Cali' to become a housing estate and the Queensway an ASDA – but not before they played host to many iconic acts of the 1960s and 1970s including Pink Floyd, Hawkwind, The Jam, The Three Degrees, and David Bowie.

In Luton, the ABC Ritz Cinema in Gordon Street became a popular live venue for 'pop package' tours in the 1960s. The Beatles had already played at the Majestic Ballroom in Mill Street in April 1963 and the Odeon in Dunstable Road in September the same year, so their return gig at the Ritz on 4 November 1964 was, not surprisingly, a sellout event with fans queuing for hours beforehand to get inside. The mayor and mayoress were also in attendance to get their photograph taken with the Fab Four for the *Luton News*. Other acts who are fondly remembered by Lutonians at the Ritz include Gerry and the Pacemakers, Roy Orbison, Del Shannon, Cilla Black, the Walker Brothers, Cliff Richard and the Shadows, Jimi Hendrix, and Georgie Fame and the Blueflames.

One artist who made a definite mark in pop culture history following his visit to the Ritz in Gordon Street was American singer P. J. Proby, whose songs 'Hold Me' and 'Somewhere', both from 1964, had catapulted him to fame the year before he came to

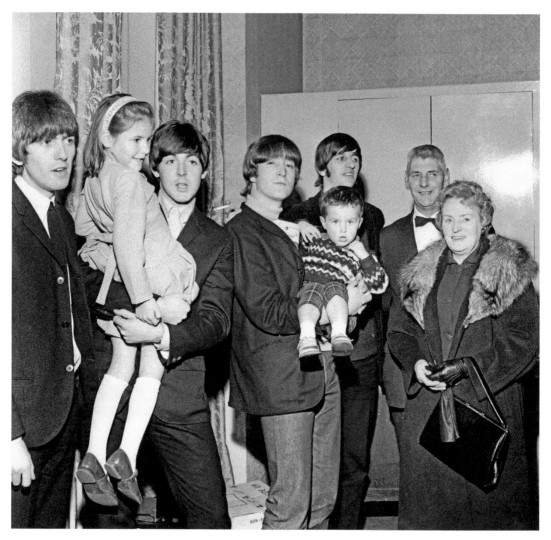

The Fab Four in town in November 1964 for a concert at The Ritz Cinema in Gordon Street. (*Luton News*)

Luton. This package tour included Cilla Black, Tommy Quickly, and The Remo Four. Two days prior, while performing on stage at the Castle Hall in Croydon, Proby's velvet hipsters had split from front to back, an event that caused concert promoters Arthur Howes and Brian Epstein some consternation. On 31 January 1965, Proby took to the stage at the Ritz. As well as screaming teenage girls, police were present in the audience to monitor the condition of the American's trousers, which again gave way halfway through the performance. The show was stopped and Proby was arrested for indecency. He was subsequently banned from appearing in all ABC cinemas in Britain and was quickly replaced the following month by Tom Jones and The Squires. All those attending were able to queue for a refund on their ticket the following day, although for diehard Proby fans, they surely got their money's worth that evening!

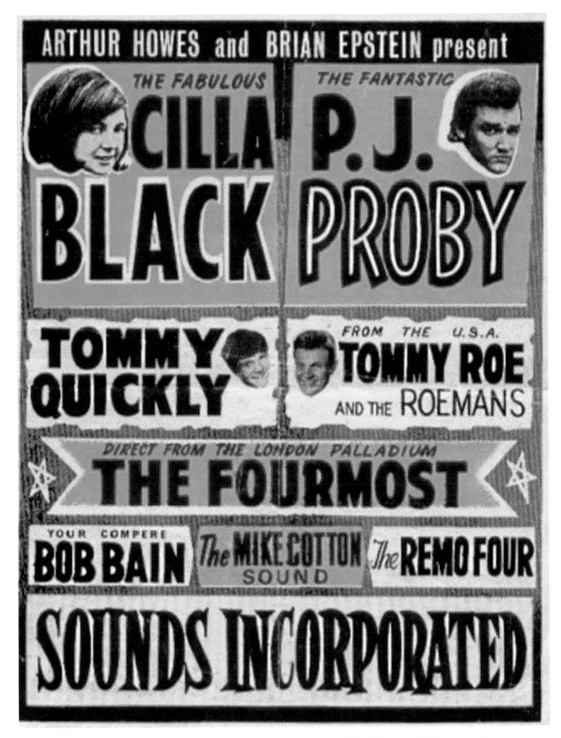

A typical 'pop package' tour from the mid-1960s featuring Cilla Black and P. J. Proby. (Author's Collection)

As well as homegrown popular music talent – original Jethro Tull and later Uli Roth drummer Clive Bunker and 1980s soul singer Paul Young are two well-known musical Lutonians – the town has a direct connection with music for the big and small screens. David Arnold, a former student at Luton Sixth Form College, has forged an international career as a Grammy Award-winning composer, scoring many successful feature films including sci-fi blockbusters *Independence Day* (1996) and *Godzilla* (1998), urban thriller *Shaft* (2000) starring Samuel L. Jackson, and Bond epics *Tomorrow Never Dies* (1997), *The World Is Not Enough* (1999), *Casino Royale* (2006), and *Quantum of Solace* (2008). His television work includes *Randall & Hopkirk (Deceased)* (2000), comedy favourite *Little Britain* (2003–06), and *Sherlock* (2010–17).

DID YOU KNOW?

The globally successful heavy metal band Iron Maiden came to Luton in 2003 during the making of their thirteenth studio album, *Dance of Death*. Formed in East London by bass player Steve Harris in 1975, Maiden are regarded as one of the most influential groups to emerge from the New Wave of British Heavy Metal (NWOBHM) in the late 1970s, with recognisable anthems including 'Run to the Hills', 'The Trooper' and 'The Number of the Beast'. As part of the production for *Dance of Death*, the band visited Luton Hoo, where photographer Simon Fowler used the grandeur of the building's interior to create a collision of medieval and Renaissance styles, which were later carried over onto the stage set for the world concert tour. This visited four continents and twenty-one countries between October 2003 and February 2004.

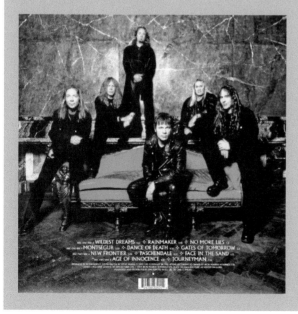

Metal giants Iron Maiden at Luton Hoo for their 2003 *Dance of Death* album. (Simon Fowler)

Born out of the economic and political climate of mid-1970s Britain, a time of power cuts, strikes and three-day working weeks, as well as a reaction to the prevailing trends in contemporary popular music, the punk movement is an instantly recognisable and influential social scene. As an industrial and manufacturing town, Luton was an ideal springboard for punk music and culture, and its role in its development, and that of the later Goth scene, is important and underrated.

The Reflex, a small group of Luton-based music promoters, was instrumental in introducing the fledgling punk music scene to the town. On 6 October 1976, they brought The Damned to the Royal Hotel in Luton for what was only their tenth ever gig, delivering a raw and powerful set that left some audience members bemused and others eager for more. Later the same month, the Sex Pistols together with The Jam played Dunstable's Queensway Hall to a sparse audience of less than a hundred people. The Pistols were two months away from their notorious appearance on Thames Television's regional early evening *Today* programme, which brought the new punk movement instant notoriety and controversy in equal measure.

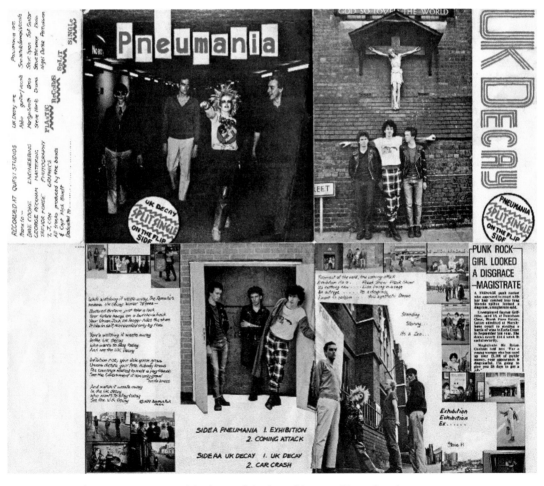

Luton punk pioneers UK Decay's 'Split Single', released in 1979. (Steve Spon)

Luton's first punk band was The Jets, who gigged out of a small terraced house in Hibbert Street. As well as Luton Tech and Barnfield College, The Jets performed at The Roxy Club in Covent Garden and appeared on the compilation LP *Farewell to the Roxy* (1978) with other groups including the UK Subs, Open Sore, and Pickets and the Plague. In Luton, The Jets were followed by homegrown punk acts The Resiztors, later to become UK Decay, and Snow White and the Sic Punks, who would become known later as Pneumania, sharing a rehearsal room at No. 130 Wellington Street, which also doubled as an outlet for punk records and clothing. During the course of 1979, the two bands collaborated to form their own Plastics Record label and booked studio space at Quest Studio in Windmill Road. The result was the 'Split Single' 7" EP featuring two tracks each side from both bands: 'Exhibition' and 'Coming Attack' from Pneumania, with the eponymous 'UK Decay' and 'Car Crash' on the reverse. The old mantra of there being no such thing as bad publicity worked well when the release of 'Split Single' received a brutal review from Danny Baker in the *New Musical Express*, generating much-needed interest in the Luton punk scene.

From 1978 onwards, a small venue in Guildford Street, the '33 Art Centre', became an important focus for punk and other genres in the town, providing rehearsal and performance space. Sadly, rather than receiving a blue plaque in recognition for its place in Luton culture, the '33', like other buildings in the area, was ultimately demolished. Gigs were also held in the Town Hall, the Baron of Beef in the Arndale, and the Cork and

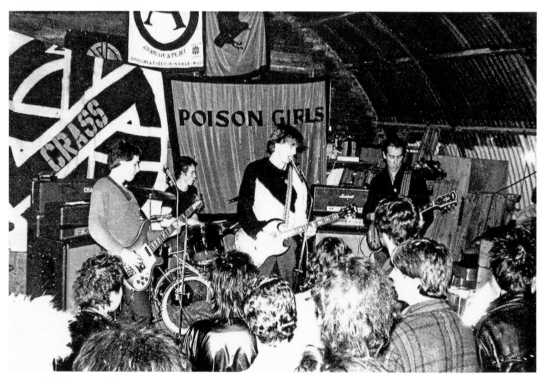

A full house at the Marsh Farm Nissan Hut in 1979. (Tim Swain)

Bull in Cumberland Street. In late 1979 a triple line-up of UK Decay, Poison Girls, and Crass crammed a full house into the Marsh Farm Nissan Hut. Decay also played with Northampton's recently formed Bauhaus at Luton Tech the following year, and 1980 saw them release a second 7" EP, 'The Black 45'. Between 1980 and the end of 1982, UK Decay toured the UK, Europe and America, and ran their own Matrix Records from premises in John Street. In the post-punk era, the band have enjoyed several reunion shows, and as part of the nationwide '40 Years of Punk' events, UK Decay's two Steve's, Spon and Abbott, gave a talk at the Hat Factory on 26 November 2016 to mark Luton's contribution to what remains an important part of cultural life in Britain.

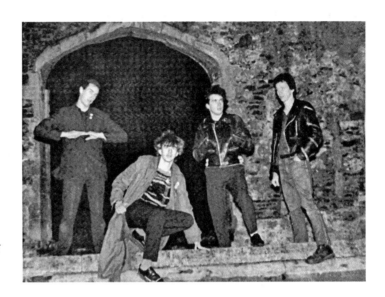

UK Decay at Clophill's eerie Old St Mary's Church for the cover of their 'The Black 45' EP. (Steve Spon)

3. Wartime Luton

At the beginning of the twentieth century, Bramingham on the northern outskirts of Luton was a tiny hamlet comprising two working farmsteads, Great Bramingham Farm and Little Bramingham Farm. It was at Great Bramingham that the conflict in the trenches created a tragedy of such appalling magnitude, which, despite the passing of a whole century and another devastating world war, still has the power to move. It may also feel familiar to anyone who has seen Steven Spielberg's epic 1998 Second World War drama *Saving Private Ryan*; but whereas Spielberg's story features a family of four American soldiers from one family lost behind enemy lines, this Luton story involves *two* families with a total of *twelve* young men, seven of whom never returned from France.

George Horsler married Ann Currington at St Margaret's Church, Streatley, on 28 April 1881 and the couple lived for the whole of their married lives at No. 3 Great Bramingham Cottages. George was the horse master at Great Bramingham Farm and between 1882 and 1904 they raised a family of fourteen children. Samuel Brightman and Sarah Woodward were also wed at St Margaret's the same year (on 14 June) and lived two doors away from the Horslers in the same small cluster of terraced cottages. Samuel was a cowman on the farm with George Horsler and he and Sarah had nine children of their own during the same period as the Horslers.

At the outbreak of hostilities in 1914, eight of George and Ann Horsler's sons – William, Edward, Albert, Arthur, George, Walter, Frank and Absolom – were called up, with only Absolom being deemed unfit to serve. William Horsler had already spent twelve years soldiering (eight of those with the 15th Hussars in India). Working as a postman at Ampthill, he joined the Military Police and was subsequently wounded and returned home. His younger brother, Albert, was also wounded and survived, but three of their siblings were not so lucky. Edward Horsler of the 8th Battalion Bedfordshire Regiment was killed on the Somme on 15 September 1916; George Horsler of the 4th Battalion Bedfordshire Regiment died during the Battle of Passchendaele on 30 October 1917; Arthur Horsler of the 20th Battalion Manchester Regiment, a stretcher bearer, was killed just over a month before the Armistice on 4 October 1918. As if the loss of three sons was not enough, the grief of the Horslers was compounded when Absolom, who escaped the carnage of the trenches, died at home two months after his brother, Arthur.

For Samuel and Sarah Brightman, the First World War left an equally devastating mark on their simple hard-working family. Herbert, Frank, Alfred, Walter and Richard Brightman were all called up, four of whom were killed in action. Alfred Brightman of the 2nd Battalion Bedfordshire Regiment was killed at Ypres on 26 October 1914; Frank Brightman of the 2nd Battalion Bedfordshire Regiment was listed as missing

THE LUTON NEWS & BEDFORDSHIRE ADVERTISER.

WAR'S TERRIBLE TOLL ON VILLAGE HOMES.

Twelve Soldiers——Nine Casualties.

Cottage Where Only One of Five Sons Returned.

Of Neighbours' Seven Sons Three Killed and Two Wounded.

Alfred Brightman, Bedfords. Killed.

Herbert Brightman, Bedfords. Killed.

Frank Brightman, Bedfords. Missing.

Richard Brightman, Bedfords. Died of Wounds.

Walter Brightman, Welsh Regt. Released.

Great Bramingham, despite its "great" in its name, is only a small hamlet lying off the main Luton - Bedford road, just before the Streatley turn is reached, and one hears very little of what happens there, because normally very little does happen. Also because it is such a small place, the sacrifices which some of the people living there have made during the war have not hitherto achieved the publicity which has been given to other cases in which the toll of the war has not been so severe, but which have more readily come to light.

SEVEN KILLED.

Five soldier sons—four of them now lying in soldiers' graves. Seven soldier sons, three of whom made the great sacrifice. These are the records of two humble families at Great Bramingham which have not only been brought to our notice, and we question whether there is another little place like Great Bramingham in the whole county of Bedford, where from two neighbouring cottages twelve sturdy men went out to fight, and only five returned, not all of these as fit and strong as when they left the land to take up arms in its defence.

Of the seven Horsler brothers who have served—an eighth was called up, rejected, and has since died—the eldest was William. He had twelve years of Army service to his credit before the war began, for as a young man, anxious to see a bit of the world, he joined the 8th Hussars, and later went with the 15th Hussars to India for eight years. When he came home from India he was transferred to the reserve, and had not long completed his term and received his discharge when the war made a new call. He was then a postman at Ampthill, and was released from the Postal service to find a fresh field of service in the Military Police. While out in France he went up the line one day when off duty to try and get some

INFORMATION ABOUT A BROTHER,

Walter, and on that visit was very badly wounded in the neck and shoulders. He was invalided out as the result of his wounds, and is still practically

disabled and in receipt of a pension for his disablement. He lives at Ashburnham-road, Ampthill, and has returned to his employment with the Post Office, Steppingley being his morning journey.

Edward Horsler was one of the many who were killed in the fighting on the Somme in September, 1916. He could probably have avoided military service altogether, as he was a married man with five little children, but the announcements scattered broadcast that "Your King and Country need you" had their effect on him. He went through his training at Ampthill Camp, and when he was placed on draft for France two other brothers who were at Ampthill Camp at the same time volunteered without success to take his place. His widow and children are living at Streatley.

Albert, the third of the brothers, went to France with the Rifle Brigade, and was wounded. He had previously worked in the Streatley district, and also for a time for Messrs. G. Kent Ltd.; now he is out of the Army again he is in the employ of Mr. Holdstock, of Chiltern Hall Farm, and lives at Dane-street.

KILLED WHILE HELPING THE WOUNDED.

Arthur Horsler, another brother, who joined the Army in February, 1917, went to France with the 20th Manchesters, then to Italy, and then to France again. He came home on leave in the summer of 1918, and he was killed on October 4th, the last time he went up the line after getting back from leave. He was one of the stretcher bearers, and was shot and killed while he was bandaging a wounded comrade, who was further wounded while he was lying on the stretcher.

George Horsler served in France with the 4th Beds, after being trained at Ampt-

hill Camp. After 15 months he came home on leave, and had been back a fortnight when he was killed at Passchendaele, the date of his death being officially given as October 30th, 1917.

Walter, one of the brothers who has now been demobilised, served in France first with the 4th Bedfords, and then with the 6th Bedfords, and it was his good fortune to come through unscathed.

Frank, the seventh brother, has now just come home from France, to which he went from Italy, and is at present on his month's demobilisation leave. Of his two years and eight months in the Army his papers state that he served two years and six months overseas. He was originally with the Warwicks, but of late has been with the Military Police.

FATEFUL OCTOBER.

Of the five sons of Mr. and Mrs. Brightman, who live only two doors away, it is a remarkable coincidence that the four who were killed all fell in the month of October.

Alfred was the first son to go. He had done seven years' service and was on the reserve when the war broke out. He was called up on August 8th, 1914, went to Landguard, and in September was in France. On October 26th he was killed. Lately his parents have received the Mons ribbon and star which would have been his had he lived, and it is understood that a rosette for the ribbon will be sent later.

Herbert Brightman was in the Army at the time of the South African War, but as he was placed on garrison duty he did not see any active service in that campaign. In November, 1915, he rejoined, and in July, 1916, went to France. After being wounded he returned to England for a time, but in 1917 he went to France a second time, and was killed on October 25th, 1917.

Frank Bright-man was called up in March, 1916, under the Derby Scheme, and went into the Bedfords. He went to France in September, 1916, when the Somme fighting was in progress, went up the line on October 12th for the first

time, and was then reported missing. No further news was ever received, so it can only be assumed that in his baptism of fire he fell unknown to any of his comrades who survived.

A TRAGIC DAY.

Richard, another brother, was exempted for a time as he was wanted on the land, but in January, 1917, he was called up and sent to Halton Camp. Within a very few weeks he was in France, and in October, 1917, he was wounded so severely that both feet had to be amputated. From a Canadian hospital at Etaples a letter was received that they hoped to pull him through, but he only lived a week, and now lies in the British Military Cemetery at Etaples. A tragic feature was that the parents received in one day an official intimation that their son, Herbert, had been killed, and also a telegram stating that Richard was in hospital, so seriously wounded that no one could go to see him, a telegram which was followed a few days later by the news that this son had also passed away.

THE ONLY ONE LEFT.

The fifth son, Walter, was called up in February, 1916, under the Derby Scheme, and went to Landguard. From there he was transferred to a Welsh battalion for service in France, and went there in July. In France he was taken very ill, and was in hospital and convalescent homes for more than twelve months. Then, during the harvesting, he was sent on farm work for a time. When it was anticipated that he would have to go overseas again, appeals were made by the Vicar of Streatley and others to the authorities, pointing out that this was the only son left out of five, and as a result he was released from the Army on compassionate grounds last July.

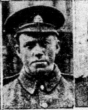
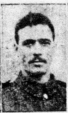

William Horsler. Military Police. Wounded.

Edward Horsler. Bedf. Regt. Killed.

Albert Horsler. Rifle Brigade. Wounded.

Arthur Horsler. 20th Manchesters. Killed.

George Horsler. 4th Beds. Killed.

Walter Horsler. 4th Beds and 6th Beds.

Frank Horsler. Warwicks and Military Police.

The *Luton News* reports the tragic losses suffered by the Horsler and Brightman families during the First World War. (Luton Culture)

in action on 12 October 1916 and his body was never recovered; his brother Herbert of the 1st Battalion Bedfordshire Regiment was wounded in July 1916 but returned to the front from England and died at Passchendaele on 25 October 1917. The same

DID YOU KNOW?

Dennis Wheatley (1897–1977), the famous thriller writer and author of the highly regarded Black Magic novels *The Devil Rides Out* (1934) and *To the Devil – a Daughter* (1953), was stationed at Biscot Camp during the First World War. At this time Biscot was still a rural location comprising the windmill and a few cottages and had yet to be incorporated into Luton's suburbs. The camp was home to the 6th Reserve Training Brigade of the Royal Field Artillery. Here new recruits were giving instruction while soldiers returning from the front recuperated before being sent back to France. Wheatley arrived at Biscot Camp on 2 February 1917. During his time there the future 'Prince of Thriller Writers' amused himself and his fellow soldiers by writing pornographic limericks involving such characters as the young curate of Eltham and the old Bishop of Buckingham! It was here that he met Gordon Eric Gordon-Tombe, who was later used as the model for the character of Gregory Sallust in several novels including *The Scarlet Imposter* (1940) and *They Used Dark Forces* (1964). Wheatley left Luton at the end of July 1917 and was sent to France. Both he and Gordon-Tombe survived the war and returned to civilian life. Wheatley joined his father's Mayfair wine business and later became a bestselling novelist. He died in 1977 aged eighty. In April 1922, Gordon-Tombe was murdered by a former business partner and his body dumped in a cesspit at a house in Kenley, Surrey. The case is known as 'The Welcomes Murder' and features a supernatural prophecy in which the victim's father, a vicar from Sydenham, dreamt he saw his son's body buried at the location it was later discovered.

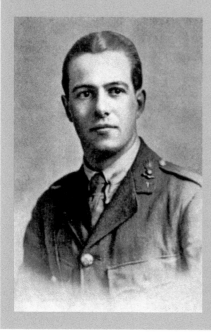

The future 'Prince of Thriller Writers' Dennis Wheatley as a soldier in the First World War. (Author's collection)

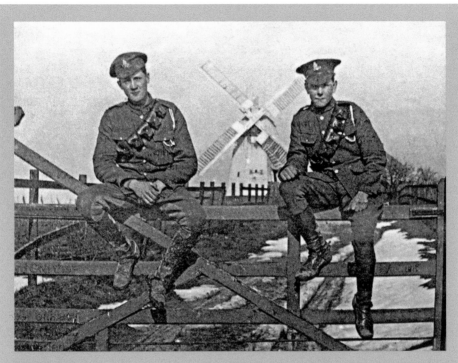

Soldiers relax near the windmill at Biscot during the First World War. (Old Photos of Luton FB group)

The Welcomes Murder. It was at Biscot Camp in Luton that Dennis Wheatley first met Gordon Eric Gordon-Tombe. (www.denniswheatley.info)

month as his brother Herbert was killed, Richard Brightman of the 4th Battalion Bedfordshire Regiment was severely wounded and died in hospital at Etaples on 10 November 1917.

If not for the actions of the Revd Cecil Mundy, the vicar of St Margaret's at Streatley, the loss of all Brightman brothers would almost certainly have been complete. Walter Brightman had been called up in February 1916, but after arriving in France was taken ill and spent twelve months in a military hospital before returning to Great Bramingham Farm where he helped with the harvest. When it became clear that Walter would soon have to return to the front, the Revd Mundy appealed to the War Office that he was the last brother out of five left to the Brightman family. The appeal was successful and Walter Brightman was released from the Army on compassionate grounds in July 1918.

The episode recalls with great poignancy the 'Bixby letter', written by Abraham Lincoln to a widow during the American Civil War, which was the basis for the story of Steven Spielberg's Oscar-winning film *Saving Private Ryan*. The cottages in Great Bramingham Lane where the Brightman and Horsler families lived still stand, while Great Bramingham Farm is now the site of Keech children's hospice.

Life in Luton and the town's contribution to the national effort during the Second World War has been preserved and recorded in great detail. In 1947 the *Luton News* compiled a two-volume account of Luton's war years, which included a detailed chronicle of all those persons killed both in action and on the home front. Hardly a road in the town did not have a household where someone was lost to the war. Manufacturing at Vauxhall was famously turned over to the production of Churchill tanks, over 5,000 of which were made, while other local factories were also redirected full time, producing munitions, parachutes and uniforms. A vivid account of wartime life including the attacks on Luton, *Blitzing Vauxhall*, was written in 2005 by Owen Hardisty, originally of Letchworth, who served as an office boy at the Vauxhall plant. Industrial buildings and factories were painted to act as camouflage against enemy reconnaissance while the Skefco works in Leagrave Road had a false roof erected, which was then painted to look like a roadway when viewed from above.

Not surprisingly this essential industry made Luton a target for German bombing – there were over 900 air-raid warnings during the course of the war, twenty-four of these involving actual assaults by enemy aircraft. A total of 107 people lost their lives, over fifty of these during the daylight raid of 30 August 1940 targeting the Vauxhall plant during the height of the Battle of Britain. On this particular day the Luftwaffe launched a total of 1,310 aircraft sorties against Britain, taking out radar stations along the south coast as well as hitting RAF airfields at Biggin Hill, Kenley, Shoreham, Tangmere and Rochford.

As well as falling bombs and parachute mines, Luton also experienced two raids by German flying bombs, or 'V' weapons. These occurred late in the war during 1944 when the fortunes of Nazi Germany were on the wane. In the early hours of Wednesday 21 June, a pilotless V-1 'doodlebug' came to earth on allotments close to Ashcroft Road in Ramridge. At the same time another V-1 exploded in fields near to the Luton and Dunstable Hospital.

The Skefco works in Leagrave Road, where a false roadway was built on the roof to confuse enemy planes during the Second World War. (Paul Adams)

Windows were blown out in both incidents, but apart from minor injuries no one was seriously hurt.

However, this was not the case with the second 'V' weapon attack on the town, which took place on the morning of Monday 6 November 1944. Just before 10.00 a.m., a V-2 rocket

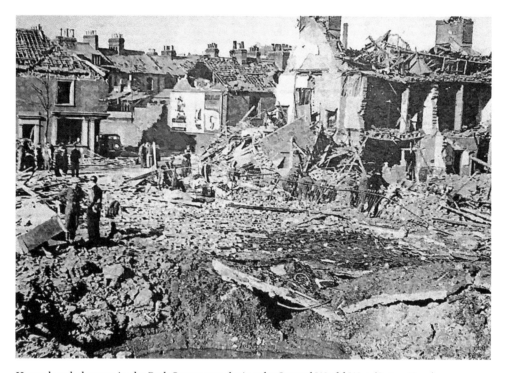

Heavy bomb damage in the Park Street area during the Second World War. (*Luton News*)

DID YOU KNOW?

Four deep air-raid shelters were constructed in Luton during the Second World War, and these still remain in place today. The Beech Hill shelter was located under Conway Road and Dunstable Road in Bury Bark. It ran for 294 yards and in wartime had a capacity of 1,411 people. The Upper George Street shelter in the town centre was located under Alma Street, Inkerman Street and Gordon Street. It ran at varying levels for 392 yards and held 1,881 people. The Albert Road shelter also covered Hibbert Street and Arthur Street. It was 460 yards long and held 2,208 people. The largest of Luton's deep shelters was located in High Town. Running under Midland Road, High Town Road and Dudley Street, it was 542 yards long and held, at full capacity, 2,600 people. The construction of the four shelters cost a total of £70,000. A proposed fifth shelter in Park Street was ultimately abandoned.

Entrance to the Alma Street deep air-raid shelter, photographed during the Luton Blitz. (Catherine Casamian)

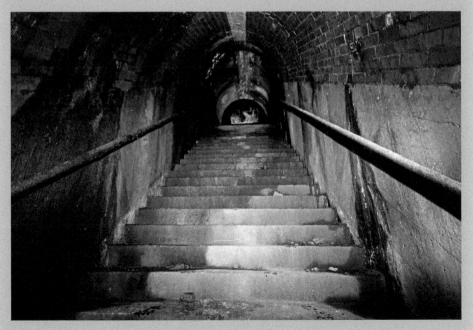

Steps leading down into the Albert Road deep air-raid shelter. (Steve John)

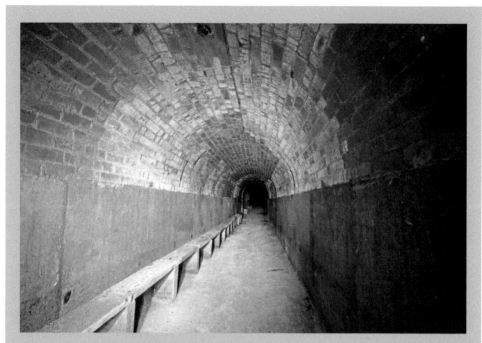

Long tunnel inside the Albert Road deep air-raid shelter, showing the concrete benches used by sheltering Lutonians. (Steve John)

packed with TNT slammed into Biscot Road adjacent to the despatch department of the Commer car factory. The massive explosion rocked the town, creating a vast crater. Nos 58–68 and 77–83 Biscot Road were completely destroyed and over 1,500 other properties were damaged. Nineteen people lost their lives and another 196 were injured.

4. Spooky Luton

The late and much-admired writer and ghost hunter Peter Underwood (1923–2014), from nearby Letchworth and who knew Luton well, established that anyone has a one in ten chance of seeing a ghost during the course of their life. Underwood was involved in what has been described as the first 'official' investigation into a haunted house, which, surprisingly, has an interesting connection with Luton itself.

'Woodfield' is a large detached house that still stands in Weathercock Lane, Aspley Guise, near Woburn. In 1947 it was tenanted by Mrs Amy Dickinson, an old lady who had lived there for around four years. The owner was a somewhat eccentric character named Blaney Key, whose actual home was on Eel Pie Island at Twickenham. In July 1947, Mr Key applied to the Luton Area Assessment Committee at the Town Hall to have his rates at 'Woodfield' reduced. His argument was an unusual one: Key stated that the house was haunted and that the ghosts, which included, so he claimed, the phantom of notorious

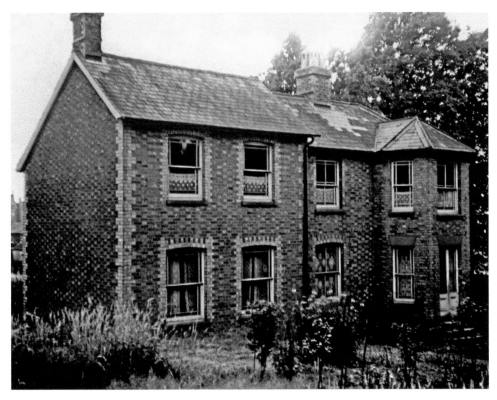

'Woodfield' at Aspley Guise, said to be haunted by the ghost of Dick Turpin. (Paul Adams)

highwayman Dick Turpin, were so persistent that his property was being devalued by all the psychical activity. According to local legend, Turpin had visited the house in the past and had helped to cover up the murder of two sweethearts who were killed by the girl's father and then with the highwayman's help subsequently buried under the cellar floor. Blaney Key claimed that phantom hoof beats were often heard coming down Weathercock Lane toward the house, a spectral figure was seen dismounting an equally ghostly horse in the garden, while a wartime evacuee, Doreen Price, testified that she had seen the apparition of the murdered girl in a room inside the house.

Councillor H. W. M. Richards from the Luton Area Assessment Committee was the man charged with investigating Blaney Key's claims and three night-time visits were paid to 'Woodfield' in September and October 1947. He was accompanied by budding ghost hunters Peter Underwood and Tom Brown; Donald West, who at that time was research officer for the Society for Psychical Research; two mediums, Florence Thompson and George Kenneth; plus the then editor of *Psychic News*, Leslie B. Howard.

The investigators spoke with witnesses and on each occasion a séance was held in the room where the murders were alleged to have taken place. Both mediums went into trance and appeared to make contact with unseen personalities connected with the alleged haunting: Florence Thompson claimed she was in touch with the young murdered girl

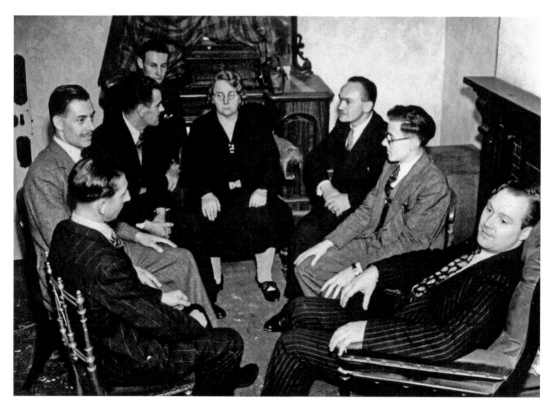

Investigators holding a séance as part of the first 'official' investigation into a haunted house. (Paul Adams)

while George Kenneth at one point seemed to become shadowed by the presence of what appeared to be the daughter's murderous father. For good measure, Kenneth also claimed that the ghost of Dick Turpin's famous horse, Black Bess, was in the room with them!

At the end of his ghost-hunting adventure, Councillor Richards came away from 'Woodfield' convinced that the house was indeed haunted. However, Blaney Key never did succeed in getting his rates reduced. At the Shire Hall in Bedford later in the year, following a private discussion with the chairman of the Quarter Sessions Appeals Committe, the appeal was eventually withdrawn. Undaunted, a year later Mr Key made

Tony Broughall, Luton's first ghost hunter. (*Dunstable Gazette*)

a second and final appeal claiming that he was unable to secure further tenants due to the continuing disturbance from the sound of ghostly hooves and the appearance of a phantom lady in white. Despite the appeal being heard, it was summarily dismissed as being 'devoid of merit and without point or substance'. The chairman, Mr Henderson, evidently did not believe in ghosts and nothing further has been heard since of the 'haunted' house at Aspley Guise.

Before his book of memoirs *Two Haunted Counties* was published in 2010, Luton's unsung ghost hunting hero was Tony Broughall, who with his wife Georgina, a clairvoyant medium, investigated many haunted locations across Bedfordshire and Hertfordshire in the 1970s. Tony, born in Ashburnham Road in 1932, was a highly regarded jazz drummer who organised the first Luton Jazz Festival in December 1958 and for several years was part of the resident house band at The Warden Tavern in New Bedford Road. In October 1977, Tony took on his most unusual case when he was asked to investigate sightings of an apparition that was quite literally appearing at its home ground – Kenilworth Road to be precise. On four occasions during the 1976/77 season, Luton Town's maintenance engineer, Fred Bunyan, together with secretary Sheila Kent, reported seeing a misty shape in the corridor outside of the changing rooms under the main stand. The fleeting figure was most often seen around 8 o'clock in the morning and both witnesses described it as a white smoky shape that quickly vanished when approached. Fred Bunyan, who showed Tony Broughall around during his visit, confirmed that he first saw the figure in 1974 and again in 1975. Following the ghost hunter's visit there were no further sightings and the Kenilworth Road ghost remains unexplained. Tony Broughall retired to Norfolk and died at Kings Lynn in 2013.

DID YOU KNOW THAT?

Luton has a direct connection with a famous lady often described as being 'the last witch in England'. During the 1970s, Gina Brealey and her husband George ran a Christian Spiritualist sanctuary at No. 47a Leagrave Road in Luton's Bury Park. Gina's mother was the Scotswoman Helen Duncan and she was the youngest of her ten children. Mrs Duncan, who was born in Perthshire in 1897, was a famous Spiritualist medium who in March 1944 stood trial for fraud at the Old Bailey, charged under the little-used Witchcraft Act of 1735. Two months before, she had been arrested when police raided one of her séances held at Portsmouth. Found guilty, she was sentenced to nine months' imprisonment, but on her release continued to hold sittings. She died in 1956 a few weeks after police raided another séance, this time in Nottingham. Helen's supporters claim she had the genuine ability to materialise spirits of the dead and a campaign continues for a posthumous pardon for her wartime conviction. Photographs of her 'materialisations' ensure that she will remain controversial for a long time to come.

Helen Duncan, the Scottish
medium whose daughter lived
in Bury Park during the 1970s.
(Paul Adams)

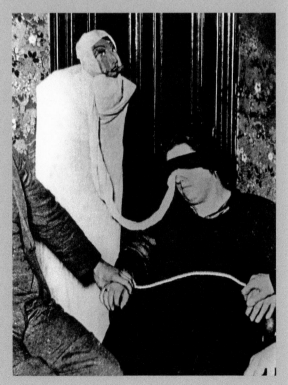

Materialised 'spirits' at a Helen
Duncan séance in the 1920s. Critics
called them the 'coat hanger ghosts'.
(Paul Adams)

Another materialisation medium who paid Luton a visit before the Second World War was Jack Webber, a former Welsh miner, who died at the young age of thirty-two in 1940. Not long before his death, Webber held a séance at a house in Rothesay Road where it was claimed he was turned upside down by the spirits and was able to leave a footprint on the ceiling of the room. According to ghost hunter Tony Broughall, the occupier Jack Keitley was so impressed that he kept the footprint as a memento of the evening for many years afterwards.

Luton's most persistently haunted building is undoubtedly Wardown Park's Museum. Sightings of a female apparition known as the 'housekeeper', consistently described by witnesses as wearing a long grey dress and with a bunch of keys on her wrist, date back to at least the Second World War. Wardown's famous lake and landscaped park was created by Frank Scargill, who successfully diverted the course of the River Lea in the mid-1870s.

Welsh medium Jack Webber, who left a footprint on the ceiling. (Paul Adams)

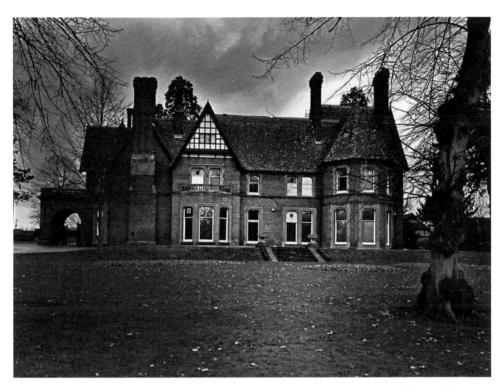

Wardown Museum, haunted for many years by the ghost of the 'housekeeper'. (Eddie Brazil)

At the same time Scargill created the museum building that we know today by rebuilding a farmhouse that stood on the site. This was built by a farmer named Robert How when the estate was known by its original name of Bramingham Shott.

During the First World War, Wardown Park was commandeered by the Royal Army Medical Corps and the former Bramingham Shott became a military hospital with an operating theatre and accommodation for up to sixty-five patients. Later the hospital was run by the Voluntary Aid Detachment of civilian nurses. In the years immediately following the end of the First World War, Luton Council used the upper rooms as office space, while the downstairs area was opened as a public restaurant and tearoom. In 1930, two ground-floor rooms were given over to the first permanent museum of local Luton history. Later this was expanded and eventually became the museum that we know today.

Since this time, unusual happenings have seemingly been part and parcel of Wardown Museum life, and the 'housekeeper' ghost has been seen many times. She was particularly active during the last war and was observed on several occasions by two ARP wardens who used the old stable block as a garage for an emergency ambulance. On quiet evenings the two men would sit in the open stable doorway drinking tea and would often see a tall female figure come out of a side door of the locked and empty museum and make her way through the park grounds towards the head gardener's cottage, where the apparition disappeared.

In 1955, two local heating engineers, Anthony Roberts and Hugh Upton, spent time in the cellar area servicing the building's boiler. With no permanent lighting available, the two men were working by the light from a lead lamp, which had been rigged using an extension cable from the ground floor. The only other person in the building, which was closed to the public at the time, was the then curator Charles Freeman, who was working in his office upstairs. Down in the cellar, Roberts and Upton became aware of light footsteps accompanied by what appeared to be the swishing sound of a lady's skirt. Looking up they both saw the figure of a tall woman wearing a dark-coloured dress, which seemed to come out of the shadows, pass close to where they were standing and almost immediately turn a corner and disappear from sight. Startled, the two engineers followed her, but it was quickly apparent that she had completely vanished. Upstairs, Charles Freeman had been totally undisturbed the whole time. The same figure was seen again in almost identical circumstances, again by workmen attending to the boiler, in 1971.

Ron Asupool worked as a custodian at Wardown Museum for ten years beginning in the early 1980s. During his time there, several visitors reported seeing the 'housekeeper' ghost, most often on the first floor in the vicinity of the main staircase. On one occasion, Ron was sitting on a chair at the head of the stairs writing up a staff rota for the coming week. A female colleague coming from one of the first-floor galleries suddenly called out to him that she could see a tall lady in a full-length dress standing at his elbow looking down over his shoulder. Looking around, he was unable to see anyone, at which point his colleague became so frightened she screamed and ran down the stairs and out through the main door! At least two other members of the museum staff reported seeing the 'housekeeper', including one man who refused to close up the first-floor galleries at the end of the day unless someone went with him. He had had the unnerving experience of seeing the ghostly woman vanish through a solid wall while alone on the first floor on a pervious occasion.

DID YOU KNOW?

At the same time as Black Magic rituals made St Mary's Old Church at Clophill world famous in March 1963, Luton had a similar satanic mystery of its own. Alerted by two local schoolboys, police and subsequently RSPCA inspector John Goodenough went to Badgerdell Wood at Chaul End – familiar to many as Bluebell Wood – where a grim sight awaited. It was 9 April 1963, three weeks after a grave had been desecrated in the ruined church at Clophill. The heads of six cows and a horse were found in an isolated part of the wood arranged in what appeared to be a ritualistic fashion. Both incidents had occurred at the time of the full moon, suggesting that members of a cult had carried out both outrages. Despite much speculation, the Bluebell Wood incident remains unsolved.

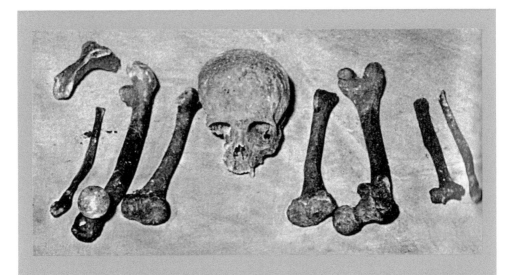

Above: The bones of Jenny Humberstone, removed from their tomb during the Clophill desecration of 1963. (Paul Adams)

Right: Newspaper cutting of the 'Caddington Horror'. (Paul Adams)

It's Black Magic among bluebells

Express Staff Reporter

A NEW Black Magic scare was started yesterday after the heads of six cows and a horse were found in a bluebell wood at Luton, Beds.

R.S.P.C.A. Inspector John Goodenough said: "There seems to be no other explanation. Two of the cows' heads had jaw bones missing.

"All were shot twice by a humane killer and it was certainly done by someone not skilled in its use. The heads were secreted in an inaccessible place, as though being hidden for a later date."

NO BODIES

Two of the missing jaw bones and two eyeballs cut in half were found later in Bluebell Wood, at Chaul End.

Inspector Goodenough added: "Two circular enclosures had been beaten down and there was a twisted tree which could have been used as an altar."

The animals' heads are believed to have been hidden in the wood about three weeks ago, when the Black Magic scare started at St. Mary's Church, Clophill, about 15 miles away, after a tomb was dug up and bones scattered about.

The heads were found by two boys. One of them, 12-year-old Stephen Kelly, of Dunstable-court, Luton, said: "The heads were scattered under bushes. There were no bodies."

Brewing has been an important industry indigenous to Luton up until recent times. A strange incident at the former Whitbread brewery in Oakley Road goes to show that ghosts can be seen when you least expect them and in the most unlikely of places. Opened in May 1969, Oakley Road was at the time the largest fully automated brewery in Europe, and its construction had been initiated by Colonel W. H. (Bill) Whitbread, the great-great-great-grandson of the brewery's founder, Samuel Whitbread.

Early on Saturday morning in September 1978, Richard Horn, a shift engineer in charge of the brewery boiler house, was asked to work through the night in order to have steam available for bottling to begin at 6.00 a.m. A short while after the appointed time, Horn noticed that the bottling had not started and, wanting to know when he could leave, decided to find out what was going on. As he climbed up a ladder into the bottling hall, he saw a tall broad-shouldered man with grey hair wearing blue overalls standing on the other side of the conveyors. He was holding a spanner and had his back to him.

Horn called out but was ignored. Thinking he had not been heard, he walked forward and again asked the man if he knew when the bottling was going to begin. Again he received no reply and at this point the man began to walk away, still with his back to the now frustrated engineer. Annoyed that he was being ignored, Horn followed him with the intention of remonstrating for the worker's rudeness, but at that moment the man reached a solid bottle-washing machine and, appearing to pass through, instantly vanished. Dumfounded, Horn walked round to the other side of the machinery but the man was nowhere to be seen. Checking with the security gate, Horn found that the bottling was now starting later in the morning and that he and the security guard were the only people present on the site.

Unnerved by his experience, Horn told no one about it other than his wife. Later, when he did speak to other workers at the plant he was laughed at, but several colleagues later admitted that they had in fact seen a similar apparition on a number of occasions. The ghost was identified as a former member of the maintenance team who had died of cancer. In June 1984, Whitbread announced the closure of its Oakley Road brewery after only fifteen years. The site where a ghost seemingly came back to work was redeveloped for housing in the 1990s and is now occupied by the Addington Way estate.

5. Murderous Luton

There is a fascination with historical crime, and particularly the crime of murder, which seems in some strange way to generate an aura of perceived gentility. Murderers from the past seem classier and appear more stylish than modern-day killers. Yet, murder is murder, often involving violence and tragedy, and although compelling, there is a terrible price to pay for those involved. Luton, like any other town in Britain, has had its share of murderous intrigue down through the years. Here is a selection of some familiar and not so well-known historical Luton murders.

Hidden for centuries, grim evidence of a violent and brutal past stretching back to the Roman occupation of Britain and beyond was uncovered by archaeologists examining the slopes of Galley Hill in 1961. Two male skeletons were recovered from a Neolithic burial mound on the summit of the hill, which dated back nearly 5,000 years. Both bodies had been chopped into pieces but the origins of the event remain obscure. Possibly both young men were the victims of a New Stone Age sacrificial ritual, or

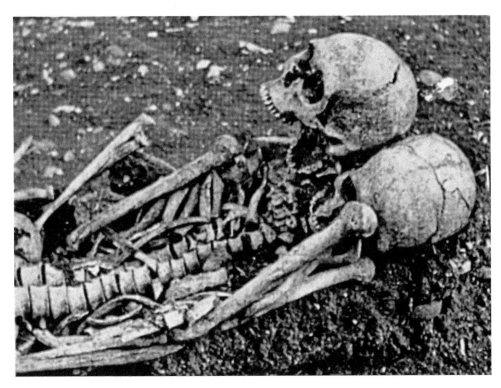

Sinister discoveries at Galley Hill in the early 1960s. (James Dyer, White Crescent Press)

alternatively they had died of natural causes and for some reason their bodies had been dismembered after death. Far more gruesome were the contents of the 'slaughter pit' discovered at the same time. Eight skeletons were found jumbled together and it was clear that they had met their ends in an act of appalling violence. An elderly couple, the woman a one-legged cripple, had been butchered and lay entwined together. There was also what appeared to be a family of three with a twelve-year-old boy whose head and limbs had been hacked from his body. Two young men together with a young woman, her head and arm severed from her body by an oblique sword cut across her shoulder, made up the grisly quota. It seems likely that this hapless group were victims of the great uprising in AD 367, when a combined force of Saxons, Picts and Scots swept southwards over Hadrian's Wall and plundered the country as far as London, killing and destroying as they went.

Up until the late 1860s, it was still possible to witness the spectacle of a public hanging in Britain. Joseph Castle, a maltster in his mid-twenties from Ware in Hertfordshire, suffered this fate on 31 March 1860 when he was executed in front of a crowd of

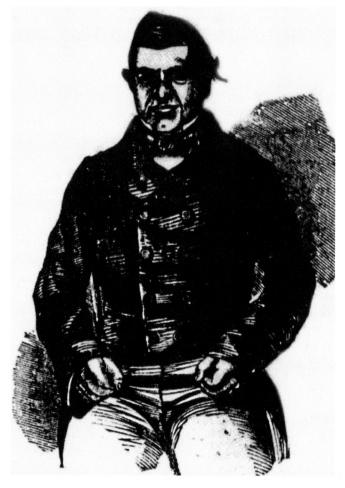

Joseph Castle, executed in 1860 for the murder of his wife near Someries Castle. (Paul Heslop/ The Book Castle)

15,000 people for the murder of his wife. Around midday on 8 August the previous year, two women walking near to Someries Castle in what is now the grounds of London Luton Airport made a horrific discovery. A blood-soaked shawl and bonnet led to the body of twenty-one-year-old Jane Castle, which lay in a hollow close to the roadway. She had been brutally attacked, her throat slashed with a knife, and it was clear that she had put up a terrific fight before finally succumbing to her killer. That person quickly turned out to be Joseph Castle, who gave himself up to police in Welwyn the same day.

At his trial at the assizes in the Shire Hall in Bedford, Castle claimed he had acted in self-defence – his wife had tried to kill him and after he had managed to get away she had turned the knife on herself. However, the wounds on the body and the way it was found made it clear that suicide was impossible and the jury took only a quarter of an hour to find him guilty. Public opinion against Castle was such that he had to be disguised as a visitor from London in order to be safely escorted into the courtroom.

The couple's story is a sad one. Joseph Castle was a jealous man who had brutalised his wife to the point that she had left the house where they lived with his uncle in Ware and had walked the 25 miles to her mother's home in York Street in present-day High Town. Her husband had followed her, and to her mother's dismay Jane had accompanied him back to Ware the following morning. They had only got as far as Someries Castle when Joseph attacked her.

The next execution at Bedford Prison was also the last one in the county to be held in public. Eight years to the day after the hanging of Joseph Castle, poacher William Worsley went to the gallows for the murder of William Bradberry, a labourer and part-time gamekeeper from Lilley. Bradberry (or Bradbury) had spent the evening of 3 August 1867 drinking in two public houses in Luton – the Bell Inn in George Street and The Old English Gentleman in Hitchin Road. As he made his way home through Round Green, he was struck down and left mortally wounded, the motive being robbery. Bradberry was taken to the Jolly Topers public house further along Hitchin Road where he died of his injuries just after 8 o'clock the following morning.

A group of local men from High Town, forty-five-year-old William Worsley, forty-year-old Levi Welch and James Day, aged twenty-one, labourers by day and poachers by night, were arrested and subsequently appeared at the Bedford Assizes. All had been in the area at the time of the assault. Charges against James Day were withdrawn after it was shown he had been searching for a lost sixpence when Bradberry had been attacked. Although both Worsley and Welch intended to carry out the robbery, it was felt that Worsley was the one who had assaulted the hapless Bradberry and it was he alone who was found guilty of murder. He was executed in front of a crowd estimated to be in the region of 4,000 by William Calcraft, the longest-serving British executioner, who officiated at around 450 hangings over a period of forty-five years. Calcraft was renowned for using the shortest of drops when dispatching the condemned, with the result that instead of a clean and instantaneous death, many felons were in fact strangled to death. Levi Welch, William Worsley's partner in crime, who had a total of eleven previous convictions for theft and poaching, escaped with his life but was given fourteen years' imprisonment in Bedford Gaol.

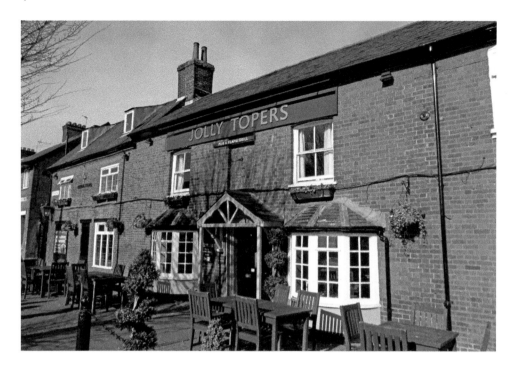

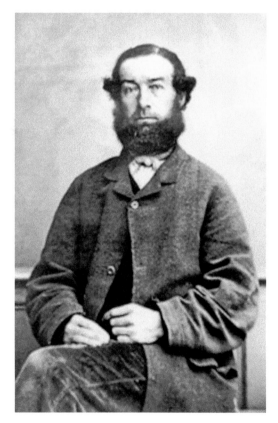

Above: The Jolly Topers in Stopsley, where the injured William Bradberry was taken on the night of 3 August 1867. (Paul Adams)

Left: Luton poacher Levi Welch, who escaped with his life after the murder of William Bradberry. (Bedfordshire and Luton Archive Service)

DID YOU KNOW THAT?

The long-established practice of publicly displaying the body of an executed felon, known as 'gibbeting' or 'hanging in chains', was officially regulated by the Murder Act of 1751. The new Act made it mandatory not to bury convicted murderers but to use their remains as a deterrent against what it called 'the horrid crime of murder'. Seven years before, on 12 July 1744, John Knott was hanged at Gallows Corner (present-day Bromham Road) in Bedford for the murder of Henry Roberts. The official record states that his body was subsequently gibbeted in chains on Luton Down, most likely the Lilley Road gallows at Galley Hill on the approach to the town from the north.

During the Second World War, the disruption imposed by wartime conditions together with the necessity of a night-time blackout to hamper enemy air raids created the conditions in which crime, and in particular murderous crime, can flourish. Between September 1939 and April 1945, eighty-nine people were executed for murder in Britain. If not for a petition for mercy containing 30,000 signatures, one Luton man would have added to this total. This is the story of the Luton Sack Murder.

At the beginning of the war, Horace Manton, known as 'Bertie', together with his wife Irene and their teenage children lived at No. 52 Trent Road in Biscot. Manton, in his mid-thirties, was a heavy-works driver employed variously by the National Fire Service and Air Raid Precautions (as an ambulance driver). His brother Percy lived with their parents in Chobham Street and worked as a greengrocer's assistant in High Town. At some point 'Bertie' moved his family to the centre of town to a small mid-terraced house, No. 14 Regent Street, a building that survived until the 1960s when it was demolished to make way for the Chapel Viaduct. In 1943 Mrs Manton fell pregnant, but life was far from harmonious – Manton accused his wife of associating with soldiers, there were frequent rows and at one point she left him for four months.

Irene Manton was last seen alive on 18 November 1943. When their children returned home in the afternoon, Manton told them that she had left to visit relatives in Grantham. As their mother had spent time away before, this did not seem out of place. The following day, early morning Vauxhall workers passing along Osborne Road noticed but ignored a large sack partly submerged in the water close to the bridge over the River Lea. Curiosity eventually got the better of two Luton Corporation employees who later the same day were checking water levels along the same stretch of river. Opening the sack, they were horrified to find the naked body of Irene Manton, trussed up with rope and battered almost beyond recognition. As well as disfiguring her face, 'Bertie', in an attempt to conceal her identity, had removed her clothes and her false teeth. His brutal efforts proved to be surprisingly effective.

Over the next two months, despite a concerted effort, Scotland Yard detectives and police struggled to put a name to the unfortunate victim in the sack. Over 200 lorry drivers who called at the nearby Vauxhall works around the time of the murder were questioned

and the records of 404 missing women were examined. Morticians carried out restoration on the corpse's damaged head and face and a profile photograph was shown in Luton cinemas with a request for anyone recognising the victim to come forward. Incredibly, Irene Manton's seventeen-year-old daughter, who still believed her mother was staying with her uncle, saw the picture but did not realise who it was. Her two brothers, who saw the same photograph in a shop window, *did* feel there was a likeness to their mother, but were also convinced she was safe.

Whether 'Bertie' Manton would have succeeded in continually covering up his wife's absence to his family is debateable. Over the Christmas period he forged several letters, which were shown to his children and seemed to allay any worries they may have had about their mother's absence. However, his undoing was to have torn his wife's clothing up and thrown it in the dustbin, rather than burning it in the kitchen grate. In the middle of February 1944, police officers looking for discarded clothing that could conceivably have come from the lady in the sack found pieces of an overcoat on the Luton Corporation rubbish tip. A dry-cleaner's label showed it had been taken at some point to the Sketchley premises in Wellington Street. Records revealed the coat had been brought in by a Mrs Manton the previous November and Chief Inspector Chapman of Scotland Yard's Murder Squad paid No. 14 Regent Street a visit. 'Bertie' was out when the policeman called but his eldest daughter showed Chapman a photograph of her mother and he immediately realised that the search was over.

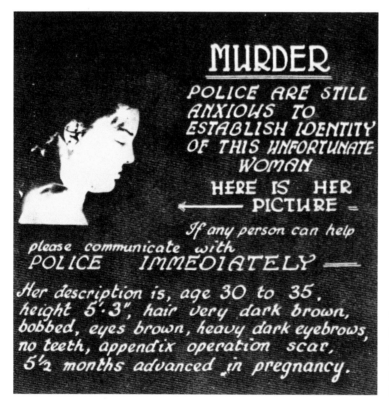

The slide shown in Luton shops and cinemas in connection with the Luton Sack Murder. (Author's collection)

When questioned, Manton denied the sack lady was his wife and produced his forged letters as proof that she was still alive and well. However, the subtle but constant misspelling of the word 'Hamstead' as 'Hampstead' did not go unnoticed, and when Chapman asked him to give a specimen of handwriting including the same word, Manton fell into the trap. Soon the family dentist confirmed that his records matched those of the dead woman and the hapless 'Bertie' was charged with murder. Realising the game was up, he quickly confessed to the crime. He had hidden his wife's body in the cellar until his children had gone to bed. Then he tied her into a sack and under cover of the blackout wheeled her over the handlebars of his bicycle through the wartime Luton streets to Osborne Road, where he threw the bundle under the bridge into the Lea.

Initially it seemed a straightforward case of manslaughter – Manton admitted he and Irene had argued and, after she had thrown a cup of tea in his face, he had lashed out in a fit of rage. However, rather than the single blow that Manton claimed, pathologist Keith Simpson showed that he had in fact subjected her to a violent and prolonged battering with a heavy object (a wooden stool that the killer subsequently used for firewood) and there was evidence of strangulation. When Manton admitted he had taken his wife by

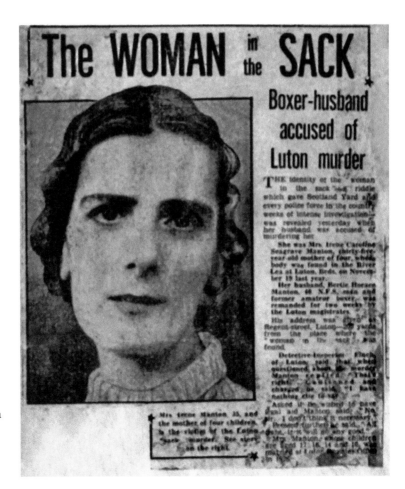

A rare photograph of Irene Manton, killed by her husband in 1943. (Jacqui Blake)

the throat, he sealed his fate and was sentenced to death. Despite the callousness of his behaviour, there was considerable public sympathy and an appeal for clemency was eventually granted. Although he escaped the gallows, the Luton Sack Murderer died of cancer three years later in prison in 1947.

If 'Bertie' Manton's appeal had failed, he would have found himself in the condemned cell at Bedford Prison. One notorious murderer who did spend his last night in that very place was twenty-five-year-old James Hanratty, executed on 4 April 1962 for the controversial A6 Murder. Hanratty's connection with Luton is that he was driven north through the town on the night of 22/23 August 1961 by the man he was found guilty of killing, Transport Research Laboratory scientist Michael Gregsten. A petty criminal, Hanratty had held Gregsten and his mistress, Valerie Storie, at gunpoint after accosting the couple in a field at Dorney Reach in Buckinghamshire. After driving aimlessly around North London, the trio reached Luton in the early hours of the morning and picking up the A6 headed towards Bedford. The lay-by where they stopped at, the appropriately named Deadman's Hill, just north of Clophill, is now part of the widened duel-carriageway. After killing Gregsten, Hanratty raped and shot Valerie Storie, leaving her for dead before fleeing in the car back to London. Storie survived the assault but was paralysed for life.

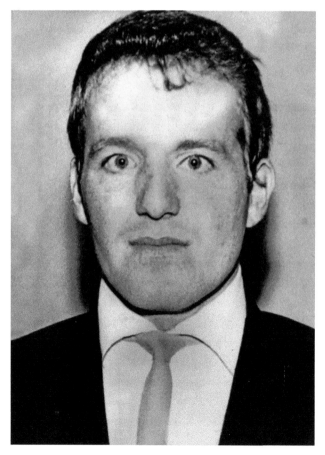

James Hanratty, the A6 Murderer. (Paul Adams)

The house in Edward Street, Dunstable, where Jack Day shot Keith Arthur in 1960. (Paul Adams)

Following Hanratty's trial and execution, capital punishment abolitionists including journalist Paul Foot championed the case as a miscarriage of justice, but in 2002 DNA evidence proved conclusively that the London-born criminal was the real A6 killer.

Jack Day was a murderer whose guilt was never in doubt. He met his death on the gallows at Bedford Prison a year before Hanratty. Born in Dunstable on 28 May 1930, Day had strong links with Luton and knew it well. His paternal grandfather, William Day, had been born in the town. Day's father, Horace, was a haulage contractor and his son followed him into the motor trade. A former dirt-track rider, in the early 1960s he was working as a car salesman. If Jack Day's interests had stayed with motorcars, things would have turned out very differently; however, it was fascination with firearms and pistols that was to lead to tragedy.

Day had married Margaret Brewer in 1955 and the couple set up home at No. 64 Edward Street, Dunstable. On the evening of 23 August 1960, Day spent some time at the Horse & Jockey pub in Kensworth where he had tested the stamina of fellow drinkers with a game of Russian roulette. The pistol he had been playing with was in his pocket when he returned home later to Edward Street. There he found Margaret talking with twenty-five-year-old local factory worker Keith Arthur, originally from Wales, who lived at No. 61 Morcom Road. Despite the couple having a young child, Day was said to be jealous of his wife's affections and, confronting the two in the front room, demanded to know why Arthur was in the house. Unconvinced by the response that he had come to see if he wanted to go for a drink, Day pulled out his pistol and shot Arthur in the neck.

Day took the body to Dunstable Downs and attempted to conceal it in an isolated outbuilding at Isle of Wight Farm, but the shooting had been witnessed by thirteen-year-old babysitter Patricia Dowling. The car dealer was arrested but claimed he had only meant to frighten his victim and that the weapon had gone off accidentally. The jury was unconvinced and despite an appeal and a subsequent delay due to a legal wrangle with *The Spectator* magazine, Jack Day was executed at 8.00 a.m. by Harry Allen on 29 March 1961. A petition of 400 signatures had been collected and forty people waited outside Bedford Prison as the sentence was carried out. He was the fifteenth to last person to be hanged in Britain.

DID YOU KNOW THAT?

The Home Office pathologist Prof. Keith Simpson, who carried out the postmortem in the Luton Sack Murder, was also involved in some of the most notorious murder cases of the twentieth century, including 'Acid Bath' murderer John Haigh, sadist killer Neville Heath, the Hanratty case, as well as John Christie, the necrophile killer of Rillington Place, Notting Hill. Simpson was one of a trio of famous pathologists known as 'The Three Musketeers', which included Prof. Francis Camps, who carried out the postmortem in the 1957 'Deep Freeze Murder' case at Wheathampstead, and Dr Donald Teare, who examined the body of guitar legend Jimi Hendrix.

Home Office pathologist Keith Simpson, whose famous cases included the Acid Bath Murder and Neville Heath. (Author's collection)

Around 6.00 p.m. on Wednesday 10 September 1969, residents in Welbeck Road, High Town, heard the sound of a gunshot. Fifty-seven-year-old Reginald Stevens, who had just closed up his shop and was making his way home, was found dying in the street. It was the beginning of the Luton Post Office Murder, one of Britain's most notorious miscarriages of justice, which would take thirty-four years to find a resolution.

Stevens was the sub-postmaster in nearby High Town Road and was the victim of a bungled robbery attempt on his shop. Chief Superintendent (later Commander) Kenneth Drury of Scotland Yard's Murder Squad soon picked up Alfred Matthews, a London petty crook with previous form for post office robbery. Fortunately for Matthews, Drury was an unscrupulous and corrupt policeman who was later jailed for eight years for his links with the London underworld. He offered Matthews immunity from prosecution if he would play his part in setting up three other London men, all known to the police, for the murder. Drury arranged an identity parade and Matthews quickly picked out David Cooper, Michael McMahon and Patrick Murphy as the men who drove to Luton from London with him to carry out the robbery. Protesting their innocence, the trio were sent to trial the following year and paid a heavy price for Drury's deceit – each were given life sentences and ordered to serve a minimum of twenty years.

Kenneth Drury's imprisonment in 1977 not surprisingly cast doubt on his other activities during his time at Scotland Yard, but it was not until 1980 that it became clear that the Luton Post Office Murder convictions were unsafe. The catalyst was an investigative

Reginald Stevens, the victim of
the Luton Post Office Murder.
(Author's collection)

book by broadcaster Ludovic Kennedy, who had previously campaigned successfully
for a posthumous pardon for Welshman Timothy Evans, executed in March 1950 for the
murder of his daughter. By this time Patrick Murphy had already been released, having
spent four years in prison. Home Secretary William Whitelaw subsequently released
Cooper and McMahon, but although the men now had their freedom, the guilty charge
for the murder of Reginald Stevens still stood.

The case of Cooper and McMahon was referred to the Court of Appeal six times in an
attempt to overturn the guilty verdict. Finally, in July 2003 the men were cleared of the
charge of murder, but it was very much a hollow victory that only the relatives of the two
men were able to celebrate. Michael Cooper had died in September 1993 aged fifty-one;
Michael McMahon was also dead, killed by a heart attack on his fifty-fifth birthday in
June 1999. Ex-Commander Kenneth Drury, the former head of the Flying Squad, had
preceded his two victims to the grave in 1984.

6. Cinematic Luton

Luton may not immediately spring to mind as being one of the most often used film locations in the country, but its place in the post-war British film industry is a major one. Being situated less than 20 miles north of the long-running film studios at Elstree and Borehamwood has been a major factor in putting the town on the cinematic map.

Castle Street makes a brief appearance in *Last Holiday*, a comedy written by none other than J. B. Priestly and produced by the Associated British Picture Corporation in 1950. Alec Guinness, in one of his early starring roles, plays a salesman given only a few weeks to live after a routine check-up at his doctor's surgery. For this, director Henry Cass used the surgery at No. 39 Castle Street on location. Today this whole section of the

Castle Street with The Dog on the right, which made a brief appearance in the 1950s comedy *Last Holiday*. (Old Photos of Luton FB group)

street, including The Dog pub on the corner of Langley Street visible in some shots, has vanished, being demolished for the Park Street dual-carriageway. The Dog, also known as the Black Dog and The Talbot, originally dated from the early 1700s, although the building in *Last Holiday* was built on the same site around 1903 and designed by London architect Joseph Johnson. The last pints were pulled there on 2 January 1968.

Another black comedy with Luton locations is 1962's *Live Now, Pay Later*, directed by Jay Lewis and starring Ian Hendry as unscrupulous salesman Albert Argyle and June Ritchie as his long-suffering girlfriend, Treasure. Scenes were shot in Milton Road in Farley Hill, while the principal Luton location here is the Wardown Court flats on the New Bedford Road. Wardown Park can also be seen in the background during one scene.

DID YOU KNOW?

Film actress Diana Dors (1931–84), who famously described herself as 'the only sex symbol Britain has produced since Lady Godiva', occasionally pulled pints at The English Rose pub (formerly known as The Rabbit) in Old Bedford Road in the 1950s. This was when it was run by the parents of her first husband, Dennis Gittins, who she met when she was filming (surprisingly enough) the comedy film *Lady Godiva Rides Again* in 1951.

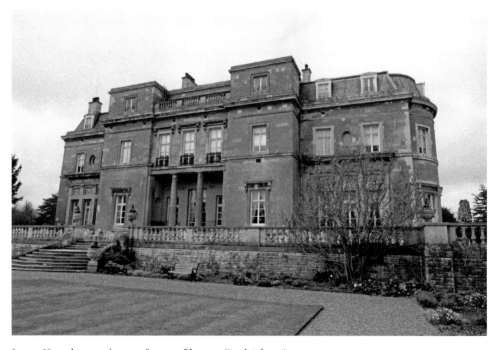

Luton Hoo, the town's most famous film set. (Paul Adams)

It is likely that you have seen Luton's most prestigious and well-used film location on a number of occasions and not realised it. Luton Hoo and its grounds have been used in over forty productions, including some of the most famous films of recent times, and by directors such as Steven Spielberg, John Landis, Blake Edwards and Stanley Kubrick. It was established in the early 1600s by Sir Robert Napier. Napier died in 1637 and the house he built here was demolished and rebuilt in the mid-1700s by the 3rd Earl of Bute. Robert Adam, famous for his neoclassical architecture and interiors, designed the new house while Lancelot 'Capability' Brown, described as 'England's greatest gardener', laid out the grounds.

Unfortunately, in 1843, a fire destroyed the complete interior of the building and what can be seen (and filmed) today is a remodelling of the repaired Luton Hoo, which was undertaken for owner Sir Julius Wernher by French architect Charles Mewès, who also designed the Ritz hotels in London and Paris. Wernher (1850–1912) was a German-born art collector and diamond merchant who became one of the richest men in England. Incidentally, for just over a hundred years Luton Hoo had its own railway station on the line between Hatfield and Dunstable. Opening in September 1860 as New Mill End, it was renamed Luton Hoo in December 1891 and survived until 26 April 1965 when the Beeching Axe closed the line to all traffic. Today the station building survives as a private house and the old railway track forms part of the Lea Valley Walk between Luton and Harpenden. During the station's heyday it was used by the Prince of Wales, who visited the estate in 1878 and 1886. Luton Hoo's royal connections also includes Queen Mary, who

Luton Hoo Station on 27 March 1965, a month before it was closed by the fall of the Beeching Axe. (Nick Catford)

was proposed to by her first fiancée, Prince Albert Victor, here on 3 December 1891, while Queen Elisabeth II and Prince Philip spent part of their honeymoon on the estate in 1947.

In 1964, Blake Edwards brought Peter Sellers' bungling French detective Inspector Clouseau to Luton Hoo for the second in his *The Pink Panther* comedies. Here the house doubles as the country estate of millionaire Benjamin Ballon, played by George Sanders. For their presentation of Leo Tolstoy's epic novel *War and Peace* in 1972, the BBC used Luton Hoo as the remote Bald Hills estate of the old Prince Bolkonsky, and for a brief period of time transformed Bedfordshire into Russian Smolensk. In May 1990, the 'Second Time Around' episode of the popular police crime drama *Inspector Morse* was filmed here.

The house and its estate has also proved popular with the doyen of secret agents, James Bond, and Ian Fleming's 007 hero has visited Luton Hoo in the form of actors Sean Connery and Pierce Brosnan. For 1983's *Never Say Never Again*, an independent reworking of Fleming's *Thunderball* novel, the grand ballroom became the Shrublands Health Clinic's gymnasium where an out of shape 007 is ordered to take a holiday. By the time Bond returned to Luton Hoo in 1999 for *The World is Not Enough*, the nineteenth film in the series, he was played by former *Remington Steele* frontman Pierce Brosnan, and on this occasion the ballroom became a Turkish casino for Robbie Coltrane's Mafia boss, Valentin Zukovsky.

Stanley Kubrick (1928–99), who created cinema masterpieces such as *2001: A Space Odyssey* (1968), *A Clockwork Orange* (1971) and *The Shining* (1980), was a film director who never wanted to work more than (it has been said) 10 miles from his home, which in his case was Childwickbury Manor near Wheathampstead. For this reason it was necessary, on a film such as 1987's *Full Metal Jacket*, to film on the Norfolk Broads instead of going on location to Vietnam! In the late 1960s, Kubrick acquired the rights to Austrian dramatist Arthur Schnitzler's 1926 short novel *Dream Story*. It would be over twenty years before he was able to realise a film version with the erotic drama *Eyes Wide Shut*, which appeared in 1999 and starred Tom Cruise and Nicole Kidman. At 400 days, the film holds the record for being the longest in continuous production, and Kubrick unfortunately never lived to see its release. He died of a sudden heart attack on 7 March 1999 only a few days after delivering his final edited version to Warner Bros. Being only a few miles from Kubrick's Hertfordshire mansion, Luton Hoo was a logical location for the mysterious country estate where Tom Cruise experiences a night-long masked orgy held in secret by a clandestine society.

More sexual escapades, this time of a more lighthearted nature, also involved Luton Hoo a few years earlier when Hugh Grant paid the estate a visit for the successful British romcom *Four Weddings and a Funeral*. As well as the ballroom, where Grant's foppish Charles finds himself sitting down to breakfast with a gathering of ex-girlfriends, the Lady Butter room is the spot where Grant humorously hides in a cupboard while a pair of newlyweds consummate their marriage at high volume in the next room. Just over ten years before and shortly before she would reinvent her career Stateside as Alexis Colby in *Dynasty*, Joan Collins had visited Luton Hoo to film the ballet drama *Nutcracker* with the tag line, 'In *The Stud* she sizzled ... In *The Bitch* she blazed ... Now in *Nutcracker* ... Joan Collins Breaks All the Rules!'

DID YOU KNOW?

Classic series *Doctor Who*, the longest-running television science-fiction series, came to the Luton and Dunstable area in 1970 when location work was filmed for its eighth-season story 'Terror of the Autons'. Flamboyant radio and screen actor Jon Pertwee (1919–96) played the third incarnation of the titular Time Lord at this point in the programme's history. His adversaries were the sinister Nestenes, an intergalactic race with a deadly affinity for all forms of plastic, created by writer Robert Holmes who had introduced the monsters in the previous season's opening story, 'Spearhead from Space'. Three locations in total were utilised for the new story. On 21 September, chase scenes involving Pertwee and his co-star Katy Manning were filmed at the Totternhoe Lime & Stone Co. quarry on the western outskirts of Dunstable. The next day and the 23rd saw climactic battle scenes enacted at the GPO Relay Station tower at Zouches Farm, Caddington. The film crew travelled back to London via a brief stop off at the Thermo Plastics factory (later Ecomold) in Luton Road, Dunstable, where scenes with villain Roger Delgado were filmed. The completed 'Terror of the Autons' story was broadcast between 2 and 23 January 1971.

Time traveller Jon Pertwee, who materialised in Luton in 1970. (BBC Enterprises)

George Mossman drives one of his coaches onto the set of Hammer Films' *Kiss of the Vampire* in 1962. (Wayne Kinsey)

George Charles Mossman, born in Luton on 9 September 1908, was one of the unsung heroes of the British film industry. His lifelong interest in horse-drawn transport was to create two significant legacies, one on celluloid and the other a nationally important museum collection. As a young man, Mossman worked for Panter's Butchers in Park Street, St Albans, as a delivery driver. In 1932 he married Mary Miles and the couple lived for a time in Saint Saviour's Crescent, Luton.

As well as working as a shopkeeper, Mossman took on a working farm at Caddington and developed his own leasing company providing horse-drawn carriages for weddings, carnivals and other events. Mossman carriages and drivers took part in the 1953 Coronation procession and for thirty-five years Mossman himself drove in the London Lord Mayor's Show. A natural progression was to supply carriages and horse-drawn coaches for period film and television work in what became a family business. Mossman and his daughters, Christine and Patricia, obtained Equity cards in order to drive carriages on screen and perform brief speaking parts. Later Christine Mossman's husband, Jonathan Dick, a prize-winning jockey originally from Epsom in Surrey, joined the business and often acted as a stunt driver. One of the first films to feature a Mossman coach was *The Corn is Green* starring Bette Davis in 1945, and nearly forty years later there were Mossman carriages in the Tarzan epic *Greystoke* (1984) featuring Ralph Richardson and Christopher Lambert.

One company that George Mossman and his family enjoyed a long and successful working relationship with was Hammer Films, famous for their homegrown style of

Gothic horror. Mossman supplied many vehicles and horses from the mid-1950s up until the early 1970s. George is the coachman in the opening scene of the classic 1958 *Dracula*, and he can be seen in some of Hammer's most highly regarded pictures including *The Curse of the Werewolf* (1960), *Kiss of the Vampire* (1962), *The Plague of the Zombies* (1965) and *Countess Dracula* (1970). Jonathan Dick played the Angel of Death, riding a winged horse onto the set of Hammer's adaptation of Dennis Wheatley's *The Devil Rides Out* in 1967. Mossman also drove the carriage for Hammer's main rival Amicus in their 1964 classic *Dr Terror's House of Horrors*. It was not all blood and gore, however – the *Carry On* comedy series also utilised Mossman's services including the stagecoach in *Carry on Cowboy* (1966) and the highwayman's coach in *Carry on Dick* (1974).

In 1991, two years before George Mossman's death, the family's vast collection of carriages was donated to the Luton Museum Service and today is the showpiece at Luton Culture's

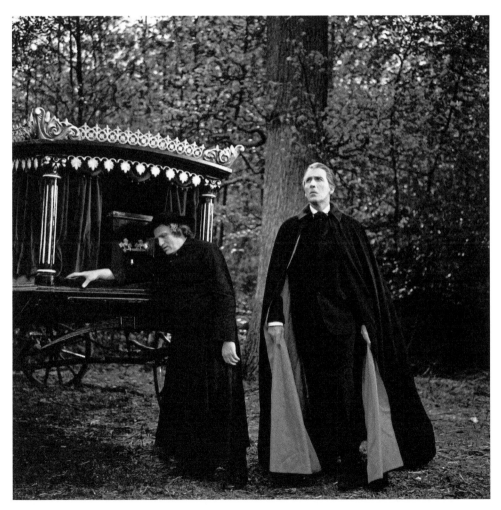

Christopher Lee as the Count with the Mossman hearse at Black Park for 1968's *Dracula Has Risen from the Grave*. (Wayne Kinsey)

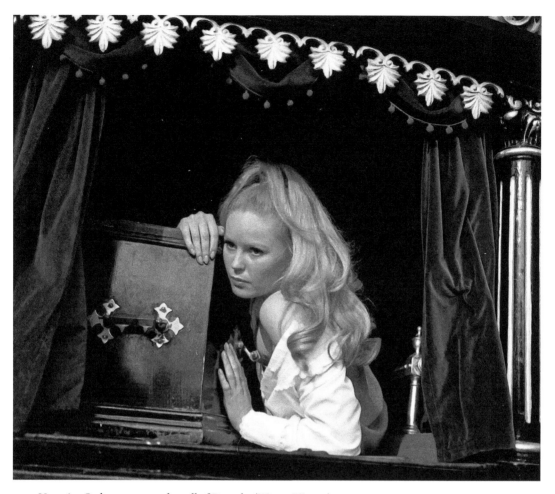

Veronica Carlson answers the call of Dracula. (Wayne Kinsey)

Stockwood Discovery Centre. Some Hammer horror coaches are part of this permanent collection. The Victorian Mossman hearse, made by John Marston of Birmingham, was used in the 1958 *Dracula* and was also driven by Christopher Lee in the later *Dracula Has Risen From the Grave* from 1968. The Victorian omnibus from *Frankenstein Must Be Destroyed* (1969) and the coach from *Captain Kronos Vampire Hunter* (1972) can also be seen.

Finally where Hammer Films are concerned, although their favourite stomping ground for many of their horror film locations was Black Park near Wexham in Buckinghamshire, they did head Luton's way on one occasion. This was for the 1972 psychological thriller *Fear in the Night*. Written and directed by Jimmy Sangster, who scripted many of their horror features in the 1950s and 1960s, this modern-day piece starred genre favourite Peter Cushing, who was joined on this occasion by Ralph Bates, Joan Collins and Judy Geeson. The slightly unglamorous Toddington services on the M1 at junction 12 were used for a brief scene where Bates and Geeson take a break on their journey to a mysterious country boarding school run by Cushing's sinister headmaster, Michael Carmichael.

The Victorian hearse at Stockwood Park. (Paul Adams)

The Victorian omnibus used by Hammer for several films in the 1950s and '60s. (Paul Adams)

DID YOU KNOW?

American-born writer Fred Freiberger (1915–2003) penned scripts for many well-known television programmes including *Scooby Doo*, *Quincy*, *The Six Million Dollar Man*, *Dukes of Hazard*, and *Cagney and Lacey*. In 1976, he was working as a producer in England on *Space: 1999*, a successful big-budget science-fiction series for *Thunderbirds* creator Gerry Anderson. As well as producing the show, Freiberger contributed episode stories under the pseudonym of Charles Woodgrove. One of these involved an alien planet inhabited by a form of sentient plant life that acted as a suitable adversary for actor Martin Landau and his crew. Driving down the M1, the scriptwriter saw a road sign which he felt would give the perfect name for the planet that up until that point had eluded him. Anderson was somewhat amused when the script for 'The Rules of Luton' landed on his desk. It was subsequently filmed between 3 and 14 May 1976 and broadcast under that title as part of *Space: 1999's* second series. Overseas, the same episode was known under several different titles: in Poland as 'The Truth of the Planet Luton', in South Africa as 'The Law of Luton', and in Japan as 'Terror of the Plant Planet Luton'.

Luton went intergalactic in 1976 for an episode of the popular sci-fi series *Space: 1999*. (ITC Entertainment)

7. Lost and Listed Luton

The change in Luton's built environment since the end of the Second World War has been a profound one. Not only whole buildings – including many of the old indigenous Victorian hat factories – have disappeared, but entire streets have vanished, and the town presents a very different appearance from that of half a century ago. Some of Luton's notable lost buildings are looked at in the following pages.

DID YOU KNOW?

There are five conservation areas in Luton where buildings and their surroundings are protected due to their important connection with the town's history and development. The High Town Conservation Area includes all premises on High Town Road from the junction with Midland Road up to and including The Freeholder pub. There are three Grade II-listed buildings: the Methodist church (built in 1897), the older Methodist church hall (from 1852 and originally a chapel), and The Painters Arms (established in 1865 and rebuilt in 1913). The Luton South Conservation Area includes Stockwood Crescent, West Hill Road, parts of London Road and Tennyson Road, and Luton Hoo Memorial Park, which was presented to the people of Luton by Alice Sedgwick, Lady Ludlow, on 12 June 1920 in memory of her son, Alex Piggot Werner, killed in action in 1916. The former Bailey Hill Water Tower is Grade II listed and was built in 1901 following a severe drought three years before. Its architect was Henry Thomas Hare (1861–1921), who included a trademark carving of a hare on every building he designed. It was converted into a private house in 2000. The Rothesay Road Conservation Area includes parts of Rothesay Road, Downs Road and Ashburnham Road, Brantwood Road, as well as the Dallow Road Recreation Ground and the cemetery, which first opened in 1854. North of the Arndale is the Plaiters Lea Conservation Area, which covers Guildford Street, John Street, Bute Street, Silver Street and Cheapside. Named as a tribute to what was a centre of the hat-making industry, several former factory buildings are Grade II listed. South of the Arndale is the Town Centre Conservation Area, which includes a large area south of George Street down to the Chapel Viaduct as well as Upper George Street and Gordon Street. The war memorial opposite the Town Hall is Grade II listed. Its architect was Sir Reginald Blomfield (1856–1942), a noted and prolific Victorian and Edwardian designer, and a contemporary of Edwin Lutyens. Blomfield's work includes the London RAF Memorial on Victoria Embankment and the Menin Gate Memorial to the Missing in Ypres, Belgium.

The war memorial, designed by noted architect Sir Reginald Blomfield. (Eddie Brazil)

Old Town Hall

The Peace Day Riot of 1919 is a notorious event in Luton's history. *The Times* for Monday 21 July reported 'Wild scenes at Luton' which had taken place two days before during a large-scale event organised by Luton Town Council to mark the end of the First World War. Earlier in the week, during the run-up to what was meant to be a celebration after four years of bitter conflict and loss, local feelings had run high. Veterans from the Discharged Sailors' and Soldiers' Association felt slighted when permission to hold a drumhead memorial service in Wardown Park was refused, and withdrew from the main Peace Day parade and banquet to be held in the town at the weekend. Late on Friday afternoon, Lady Wernher offered to hold the service in the grounds of Luton Hoo at a later date, and although this was accepted, there was still an undercurrent of resentment among many former servicemen the following day before the memorial could be organised.

Lutonians survey the scene after the Peace Day Riot. (Old Photos of Luton FB group)

Luton's Peace Day parade began well with a detachment of soldiers agreeing to take part. However, several discharged combatants still refused to take part and things came to a head after the procession had halted at the Town Hall to hear an address by Mayor Henry Impey. After being heckled, Mayor Impey refused to be interviewed about the veterans' grievances and, as the mood began to grow ugly, took refuge inside the Town Hall itself. A large body of people rushed the entrance and as the building was stormed by angry protesters, the mayor made a hasty escape through a rear door. Once inside, the crowd vented its anger, throwing furniture out into the street and tearing down decorations and electrical illuminations. After a time, the crowd was persuaded, for the safety of several women and children present, to leave the Town Hall and ordered was restored. A delegation, which marched in protest to Henry Impey's house in London Road, was also dissuaded from taking things any further.

However, the lull proved to be very much the eye of the storm. As afternoon turned into evening, the crowd returned and there were further assaults on the Town Hall that the police were unable to repel. Fires were started in several offices and the brigade that responded were themselves pelted with stones and bottles before having their hoses cut. Several policemen were injured and, in what is perhaps the most famous incident after

TOWN HALL BURNT BY RIOTERS.

FIREMEN STONED.

WILD SCENES AT LUTON.

During rioting at Luton on Saturday night and early on Sunday morning damage amounting to a considerable sum of money was done. The Town Hall was stormed on Saturday afternoon in order to wreck the Assembly Room, where a Peace Banquet was to be held to-night.

At night the place was again raided, and eventually set on fire. Riotous scenes followed in which police and firemen were injured and taken to hospital. The Town Hall, with all its contents, was destroyed, only the four walls remaining.

For more than a week before the Peace Celebrations there had been high feeling in the town, chiefly owing to the fact that the Discharged Sailors' and Soldiers' Association had been refused the use of Wardown Park for a drumhead memorial service in memory of the fallen. Instead, they were offered the choice of two recreation grounds, neither of which was considered suitable; but the authorities would not alter their decision. Lady Wernher afterwards offered the Association the unrestricted use of her place at Luton Hoo, which was accepted.

Meanwhile, the two local associations of ex-service men withdrew from participation in the official celebrations; it was rumoured that steps would be taken to prevent the holding of the Peace Banquet, and counter-demonstrations on Saturday were hinted at.

All the special constables were called out for duty on Saturday, but in the morning it was thought that there would be no trouble, and that they would be required to assist only in regulating the traffic in the streets during the procession and afterwards at the park. The procession started off without incident, and at the last moment a detachment representing the Comrades of the Great War was persuaded to join in, although the discharged soldiers, who considered they had a fresh grievance because an offer by Lady Wernher to entertain them and the children had been kept from their knowledge until late on Friday night, still declined to take any part.

How *The Times* reported the 'Wild Scenes at Luton'. (*Times Archive*)

the destruction of the Town Hall itself, a piano was enthusiastically looted from Farmer's music shop to accompany a mass rendition of Ivor Novello's sentimental war song 'Keep the Home Fires Burning'. Finally, after several hours order was eventually restored as armed troops from Biscot and Bedford dispersed the crowds and continued to patrol the streets well into the following day. Much damage was found to have been caused to shops and business premises in the town centre, while Luton's Peace Day had ended with the old Town Hall reduced to a smouldering shell.

DID YOU KNOW?

Those arrested following the Peace Day Riot were tried at Bedford Assizes in October 1919. Among the accused was forty-year-old Maud Kitchener, who it was alleged had urged the crowd to attack the police and the fire brigade while dressed up in a soldier's uniform. On 24 October, eight people were found guilty of various charges connected with the Town Hall debacle. They included Frederick Plater, who was sentenced to three years' penal servitude for rioting and attacking three policemen; George Fowler was given fifteen months' imprisonment for rioting and assaulting two policemen; Frederick Couldridge, who claimed he was the victim of mistaken identity, was handed eighteen months' imprisonment for assaulting the chief of the fire brigade; George Heley, a sailor, was likewise found guilty of assault and went to prison for twelve months, as was Albert Smith, who also received fifteen months in Bedford Gaol.

The old Town Hall destroyed in the Peace Day Riot had stood for over seventy years. It had been built to a design by local architect John Williams in 1847. At the end of the Crimean War, a public subscription fund raised money, which enabled a clock tower to be added to the building's main elevation onto George Street. Following the events of 21 July 1919, the ruins were cleared away and the site stood empty for over a decade.

In 1930, the town council organised a new Town Hall by competition, requesting designs from interested architects with a prize of £500 going to the winning entry. This was given to northern practice Bradshaw Gass & Hope of Bolton, who had successfully completed a number of public and municipal buildings in previous years. These included town halls at Lewisham, Trafford, and Wimbledon, as well as libraries in Bolton and Stockport. Several more years were to pass before the present-day Town Hall was completed. It was officially opened on 28 October 1936 by Prince George, Duke of Kent. A passionate aviator, the prince was commissioned into the RAF the year after his visit to Luton. He was killed in August 1942 in an air crash near Caithness in Scotland. Today, Luton's new Town Hall continues to be the centre of local authority administration. The building was given Grade II-listed status on 27 August 1998.

Above: Clearing the site for the new Town Hall in the early 1930s with the Carnegie Library in the background. (*Luton News*)

Left: Prince George, Duke of Kent, who opened the new Town Hall on 28 October 1936. (Author's collection)

Carnegie Library

The Scottish-born steel magnate Andrew Carnegie (1835–1919) was not only one of the richest men of all time, but is also regarded as one of the most outstanding philanthropists of his generation. After many years in business in America he spent the last twenty years of his life as an educator, donating money for various public projects in many countries across the world. One of these was the creation of the Carnegie Library, a public building for which Carnegie provided the finance for construction in return for financial commitments from the town authority where they were built. The local authority was required among other things to provide the land where the library would be built, pay for the maintenance of the building and the wages of its staff from public funds, and to ensure that the facility remained free and open to all. The first Carnegie Library opened in his birthplace of Dunfermline in 1883, and between that year and 1929 over 2,500 such libraries were built in the United States, Great Britain, Australia, South Africa, New Zealand, Belgium and France.

Luton's Carnegie Library (or Free Library as it was also known) was opened by the American Ambassador Whitelaw Reid on 1 October 1910. It stood on a prominent corner site opposite the Town Hall and adjacent to St George's Square. Andrew Carnegie himself was present for the opening and afterwards was presented with the Honorary Freedom of the Borough in appreciation of his funding of £12,000 in order for the building to be

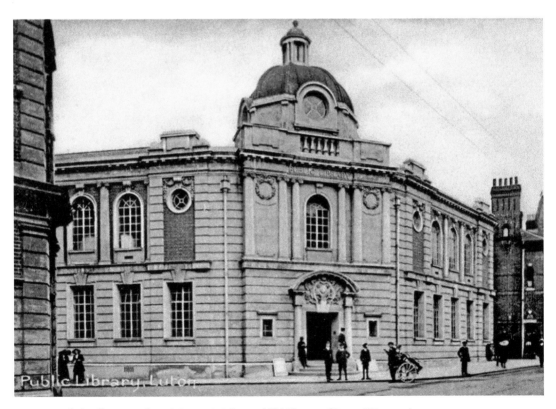

Luton's fondly remembered Carnegie Library. (Old Photos of Luton FB group)

established. The library was laid out over two floors together with a basement. It lasted until the building of the present-day Central Library in 1962, after which the old Carnegie building was demolished. Despite its cramped and overcrowded interior, Luton's Carnegie Library was much admired and its removal was felt by many to be a mistake. Today the site of Andrew Carnegie philanthropic endeavours in Luton has been replaced by a burger restaurant.

Alma Theatre

If accounts are to be believed, the Alma was a building with a curious history. It opened on 21 December 1929 as the Alma Kinema presenting both films and live variety acts. The building had to its advantage an impressive circular foyer, created by the prominent corner location at the junction of the New Bedford Road and Alma Street. There was also a restaurant and a ballroom. The very first film shown was Frank Lloyd's *The Divine Lady*, which starred Corinne Griffith as Lady Hamilton and Victor Varconi as Horatio Nelson. A feature of the times was the illuminated Compton organ, which rose on a hydraulic lift to provide musical interludes between films. The organ was first played by Herbert Dowson, who was the resident organist at St Margaret's Church, Westminster, for many years. The Alma existed for just over thirty years, sometimes known as the Alma Theatre and later as the Cresta Ballroom. Live performances included wrestling and circus acts – a famous photograph from the *Luton News* shows an elephant being pushed through the scenery dock doorway in Alma Street. The old Alma finally closed in July 1960 and was demolished the following year. Since then the site has been occupied by the Cresta House office block.

For many years the Alma had the local reputation of being a cursed building. According to Luton ghost hunter Tony Broughall, this stemmed from the time that the Alma Kinema was first built, when old houses on the site were cleared to make way for the new development. These were sold over the heads of the tenants living there at the time, forcing several families to find alternative accommodation. The resentment this caused led to tales of a curse being put on the new Alma Kinema, which gained some credibility when a workman was killed during the course of the building's construction. Much later, when the Cresta Ballroom was being demolished, the curse still seemed to retain some of its power as the first demolition contractor was defeated by the sheer size and strength of the old building – some of the brick walls were 9 feet thick – and was bankrupted after six months. A second contractor took over, but it was another year before the site was completely levelled. Harold Hall, the musical director who worked at the Alma in the 1950s, is said to have had an experience alone in the building late one night which scared him so much he would never discuss what had happened.

It is somewhat befitting this sinister reputation that one artist who trod the boards at the Alma was none other than horror star Bela Lugosi, who gave twelve performances of a stage production of Bram Stoker's *Dracula* in 1951. Other stars of the day who also performed there include Maurice Chevalier, Elsie and Doris Waters, Hughie Green, Julie Andrews, Derek Roy, and Dick Emery.

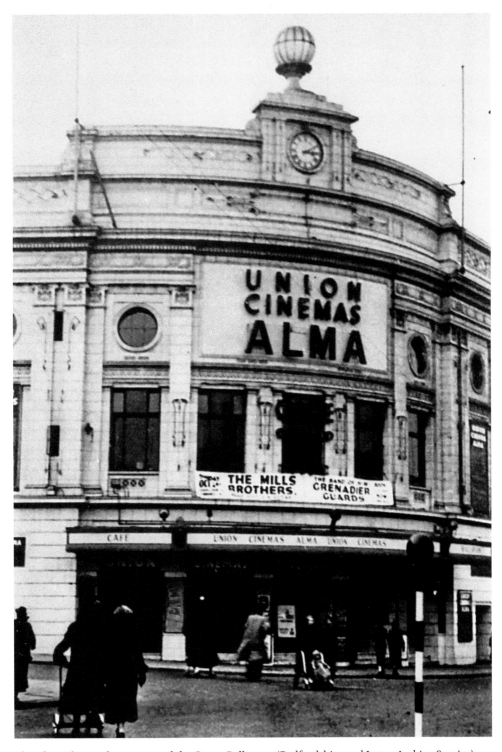

The Alma Theatre, later renamed the Cresta Ballroom. (Bedfordshire and Luton Archive Service)

Former houses on the future site of the Alma Theatre. (Old Photos of Luton FB Group)

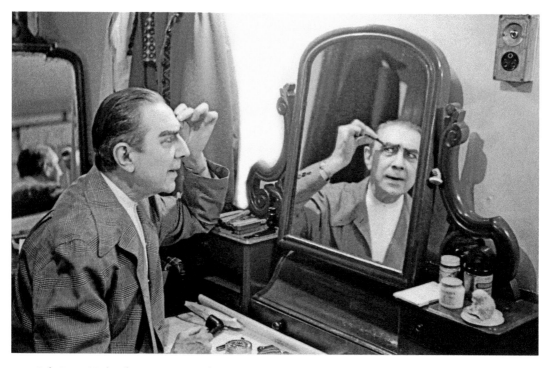

Bela Lugosi in his dressing room at the Alma Theatre. (*Luton News*)

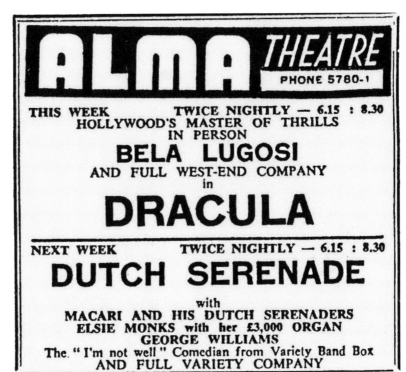

Advertisement for the touring production of *Dracula* in 1951. (Andi Brooks)

The Grand Theatre

A building that lived up to its name, the Grand in what was once Waller Street is another of Luton's entertainment venues that has fallen to the march of time. The first to cater for large touring productions, it was built for local theatre impresario Reginald Turner and had a seating capacity of 1,500 people. The official opening took place on 10 December 1898 when Lillie Langtree gave the opening address and read out telegrams of congratulation from, among others, Sir John Blundell Maple, the MP for Dulwich (who also lived at Childwickbury Manor, later home, as we have seen, of Stanley Kubrick), and noted Shakespearean actor Henry Irving. Mrs Langtry was a famous socialite and actress who ten years before had been the mistress of Albert Edward, Prince of Wales. The first play to be performed at the Grand was the William Greet Company's production of Wilson Barrett's *The Sign of the Cross*, which opened to a full house. For nearly sixty years the Grand presented both live stage plays as well as films, and following the end of the Second World War briefly became a repertory theatre offering a new play every week. Post-war austerity finally took its toll and the theatre closed in 1957 and was demolished two years later, a sorry end briefly captured on the silent film *As We Were – Luton 1926-1976*, held in the East Anglian Film Archive. Today all trace of this impressive piece of Edwardian grandeur, together with the street on which it stood, has been obliterated by the Arndale development.

The Grand Theatre in the former Waller Street. (Old Photos of Luton FB group)

Edwardian beauty Lillie Langtry, who officially opened the Grand Theatre in 1898.
(Author's collection)

8. Geographical Luton

Like most towns and cities, Luton's street names are a unique record of the past. Here you will find silent reminders of people, places and events which have fallen to the inevitable march of time. As Luton gradually expanded in size during the Victorian era, surrounding villages such as Stopsley, Limbury, Leagrave and Biscot were amalgamated and new street names were created, while existing ones were changed. Here are a few with some obvious and not so well-known connections to Luton's historical past.

Austin Road

Luton historian William Austin, born in the town in 1850, has been recognised with both a Leagrave street and a primary school named after him. His father was Lutonian Thomas Austin, a registrar and superintendent, while his mother Sarah was born in Tring in Hertfordshire. William qualified as a solicitor and lived at various addresses in Luton including Dunstable Road and Cromwell Road. As well as a lengthy account of the Crawley family of Stockwood Park, he wrote a two-volume *A History of Luton and its Hamlets*, published posthumously in 1928, the same year as his death.

Neville Road

Formerly Milton Road, the name change of this Limbury Street occurred in December 1928. The House of Neville played an important role in the Wars of the Roses, and the Neville Earls of Warwick and Salisbury took part in the First Battle of St Albans in 1455. However, I am inclined to believe that the new name refers to one of Luton's long-established building firms, T & E Neville, originally of Castle Street but since the beginning of 1968 relocated opposite the Marsh at Leagrave. Founded by Thomas Neville in 1875, the company has played a significant role in shaping the urban landscape of the town, and many familiar buildings have been built by them over the years. These include The Dog pub and the Carnegie Library already encountered, the original Sainsbury's at No. 74 George Street, shops in Chapel Street, the Woodside vicarage, Flowers' Park Road brewery, the Electrolux works in Oakley Road, St Thomas' Road School in Stopsley, Leagrave County Primary School, Barclays Bank in George Street, St Augustine's Church in Limbury, and the St Mary's Church extension. Like many building firms, Tom Neville and his brother Edward made good use of the skilled carpenters and joiners employed in the firm for coffin making, and early on established an undertaking business in 1878.

Nunnery Lane

This road in Limbury gets its name thanks to a historical mistake by a former Luton shoemaker. In 1855, William Austin, a local cobbler, published a thirteen-part history of the local area, which contained a reference to 'a considerable house for Nuns founded

The Moat House, Luton's oldest secular building. (Eddie Brazil)

by Roger, Abbot of St Albans, and dedicated to the Holy Trinity'. This convent was, according to Davis, located at Limbury-cum-Biscot, and at the time of the Dissolution of the Monasteries in 1538 it was valued at £143 18s 3d. When Luton Council began its changes to the town's street names, it was felt appropriate to honour this historical fact by naming the lane between Riddy Bridge and Biscot vicarage Nunnery Lane, and this was agreed at a council meeting on 13 December 1928. Unfortunately, William Davis had confused Biscot in Luton with the nunnery at Markyate Cell on the A5 south of Dunstable. William Austin, who we have already met, noticed the mistake and corrected it in his book, but there was no going back as far as the naming of Nunnery Lane was concerned. Luton's oldest secular building is The Moat House, which was built as a Norman manor house between 1370 and 1400. The building has not always been thatched and a famous inscribed plaque from the cellar describes a fall of hailstones the size of golf balls in the year of the Great Fire of London – 1666.

DID YOU KNOW?

When Boyle Street in High Town was redeveloped in the 1970s, architects named the newly created housing complexes – Elgar Path, Berkeley Path, Butterworth Path and Walton Path – after four of Britain's greatest composers. Sir Edward Elgar (1857–1934),

famous for his *Enigma Variations* (1899) and *Cello Concerto* (1919), was knighted in 1904. Sir Lennox Berkeley (1903–89) was Professor of Composition at the Royal Academy of Music and wrote an opera in 1954 about the love affair between Horatio Nelson and Lady Hamilton. The musical career of George Butterworth (1885–1916) was tragically cut short by his death on the Somme during the First World War. His most notable works are *The Banks of Green Willow* (1913) and his settings (between 1911 and 1912) of A. E. Housman's poems, 'A Shropshire Lad'. Sir William Walton (1902–83) wrote many concert works, although some of his most popular pieces are the *Crown Imperial* march for the 1937 Coronation of George VI and music for the 1969 film *The Battle of Britain*.

Sir Edward Elgar, one of Britain's finest composers.

Sir Lennox Berkeley, former
Professor of Composition at
the Royal Academy of Music.
(The Lennox Berkeley Society)

George Butterworth, a fine composer
killed during the First World War.

Sir William Walton,
famous for his stirring
coronation and film music.
(The William Walton Trust)

Hucklesby Way

A relatively new addition to Luton's streets, this gets its name from Asher Hucklesby, the 'Hat King', a prominent Victorian administrator, businessman and entrepreneur, who held the office of mayor on five occasions. Born in Stopsley in 1846, Hucklesby became one of the town's prominent hat manufacturers, owning property as well as the old Bond Street thoroughfare, which linked his hat warehouses to the railway station. A philanthropist, Hucklesby instigated the purchase of Wardown Park by Luton Council, and as well as being mayor also served as a Justice of the Peace. His former residence in the New Bedford Road is now the Leaside Hotel. Asher Hucklesby died in 1908 and after a prominent civic funeral was buried in Rothesay Cemetery.

Inkerman Street

Now much altered since it was laid out in the mid-1860s, we have to go back to the Crimean War for the naming of this town centre street. The Battle of Inkerman took place on 5 November 1854 close to the Tchemaya River in what is present-day Ukraine. Massed

The old Hucklesby hat factory at the corner of George Street and Bond Street. (The Book Castle)

forces of British, French and Russian troops and cannons fought for several hours, at the end of which over 4,000 men lay dead. Described as 'The Soldier's Battle' due to the ferocity of the fighting, it was a decisive win against the Imperial Russian Army. The war, which began in October 1853, ended with the signing of the Treaty of Paris on 30 March 1856.

DID YOU KNOW?

Luton has a surprising connection with film director Francis Ford Coppola and his epic Vietnam war film from 1979, *Apocalypse Now*. One of the most famous films of the 1970s, Coppola based the theme of his story on a short novel by the Polish-British writer Joseph Conrad (1857–1924). In 1899, Conrad wrote *Heart of Darkness*, which described a sailor's journey up the Congo River in Africa in search of an ivory trader named Kurtz, who has joined a tribe of natives and descended into savagery. Coppola used this basic plot but updated it to the late 1960s. Martin Sheen plays Captain Willard, who undertakes a similar (and in keeping with the times, psychedelic) journey along a jungle river through war-torn Vietnam to find

Marlon Brando's psychotic Colonel Walter Kurtz. After writing *Heart of Darkness*, Joseph Conrad lived for a time in the farmhouse adjacent to Someries Castle, where he worked on his pre-Russian Revolution novel *Under Western Eyes* (1911).

Polish author Joseph Conrad, who lived near Someries Castle in the early 1900s. (The Joseph Conrad Society)

Stuart Street

Stuart Street was named after the Scottish nobleman John Stuart, 3rd Earl of Bute, who held the manor of Luton and built Luton Hoo. Stuart, who was born in 1713, was British prime minister for less than a year in the 1760s but was considered a lacklustre statesman, and a proposed Cider Tax (of four shillings on every hogshead of cider) didn't add to his popularity. 'Jack Boot', a derogatory eighteenth-century expression, is thought to have originated from his performance in Parliament. Stuart died on 10 March 1792 aged seventy-eight and is buried in the St Mary's Chapel at Rothesay on the Isle of Bute. Rothesay Road, Rothesay Cemetery and Bute Street are also named after the Stuart family seat on the Isle of Bute, and Luton historian Howard Chandler has identified several other Luton streets that have Bute and Stuart connections. These include Dumfries Street (after the 2nd Marquess of Bute's title of Earl of Dumfries in 1803) and Hastings Street (after his marriage to Lady Sophia Hastings in 1845). Windsor Street is likely named after the 1st Marquess of Bute's obtained the title Earl of Windsor in 1796, and Collingdon Street, named for Thomas Collingdon, secretary to the Bute Estate and steward of Luton Hoo in the 1830s.

Wenlock Street

Mention of Someries Castle brings us finally to John Wenlock, the 1st Baron Wenlock, after whom this street in High Town is named. Wenlock was a diplomat and soldier at the time of the Wars of the Roses in the fifteenth century. During the First Battle of St Albans in 1455 he fought for the Lancastrians, but by the time of the Battle of Blore Heath in Staffordshire in 1459 he was a Yorkist. Two years later he became a Knight of the Garter after storming the Tower of London. In 1430, Wenlock began building a fortified manor house close to what is now the site of London Luton Airport, on land that was once owned by William de Someries. The construction of this dwelling was unusual for its time as it is regarded as being one of the first clay brick buildings in the country. However, it was never completed and all that remains today is a section of the original gatehouse. In the mid-1400s, Wenlock served as High Sheriff of Bedfordshire and Buckinghamshire, and was also Parliamentary Speaker. Despite several successful military campaigns, John Wenlock's luck ran out on 4 May 1471 when he was killed (fighting again for the House of Lancaster) at the Battle of Tewkesbury. The fifteenth-century bronze Wenlock jug, held at the Stockwood Discovery Centre, may have been made for him, while the Wenlock Chapel in St Mary's Church has a stained-glass window dedicated to his memory.

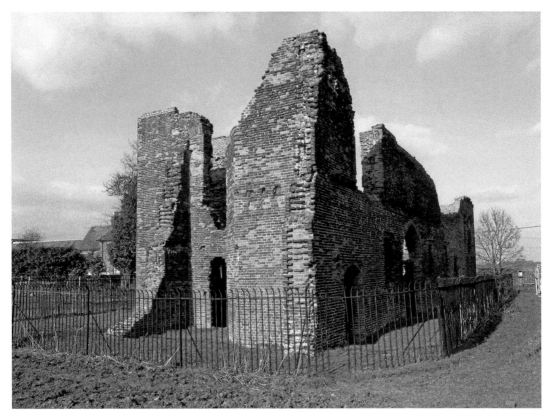

The ruins of Someries Castle, said to be haunted by the ghost of its builder, Sir John Wenlock. (Paul Adams)

9. Walking Secret Luton

Luton today is a town where most often you have to look up to appreciate the history of the past. Above modern aluminium and glass shopfronts, old buildings reveal their former lives. The past also survives in a wealth of archive and personal photographs. In an attempt to combine these I close this book with two suggested walks around the town which pick up some of the facts and figures already encountered, plus additional historic events and locations.

War and Wardown – Guided Walk

This first walk covers High Town and the Old Bedford Road/Wardown area. It starts in St George's Square and is roughly 2.5 miles. Walking time is around two hours, but if it's a nice day then why not spend some time in Wardown Park or the museum before you head back.

Set off northwards along Bridge Street in the direction of the railway station. The site of the Galaxy on the left, as many know, was the former Co-op department store; it has

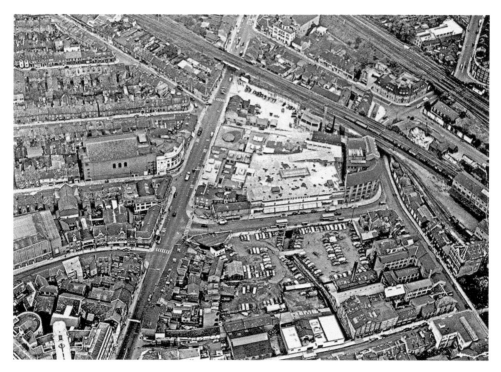

An aerial view of Bridge Street showing the old Co-op building, the Crown & Anchor public house, the Alma Theatre and the Mission Hall opposite the Royal Hotel. (Old Photos of Luton FB group)

also been a brewery and a cattle market. Central Library, built in the early 1960s, was opened by the Queen on 2 November 1962 – a time capsule created by Rotheram High School was buried in the foundations.

Go along Guildford Street and cross over the Busway. The Royal Hotel was an early punk music venue and now long gone is the former Mission Hall, which used to stand next to the railway line on the opposite corner. Go under the bridge and take a quick trip along the new Hucklesby Way. Just before the new station car park building there is a gap in the metal retaining wall and you will see a bricked-up entrance into the Midland Road deep air-raid shelter.

Go back to the bottom of Midland Road and walk on up the hill. Turning left into Dudley Street, the former Merida hat factory is the large building on the left. The Luton Grace Fellowship building was built for the former Dudley Hat Manufacturing Co. Ltd in 1903. Carry on up Dudley Street. On the right just before the junction with Wenlock Street is the narrow Albion Path, which leads into what was Albion Road. Here in 1972 the house (now demolished) of John and Marion Smith was affected for several weeks by a poltergeist outbreak.

Carry on down Dudley Street, past the Composers Estate and turn left into North Street. On the corner, now replaced by a new block of flats, was the old North Star pub. Go to the end of North Street and turn right into the Old Bedford Road. On the corner is the former pub, The Rabbit (now The English Rose), with its Diana Dors connection. Directly opposite North Street is the Nursery Cottages Nursing Home, built on the site of the Old Bedford Road School. Just before noon on 15 October 1940, the children were sent to the school air-raid shelter following a raid warning. Walk up the Old Bedford Road until you

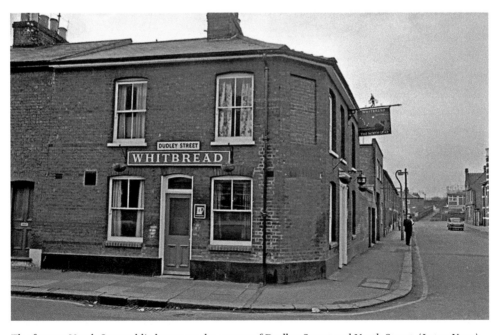

The former North Star public house on the corner of Dudley Street and North Street. (*Luton News*)

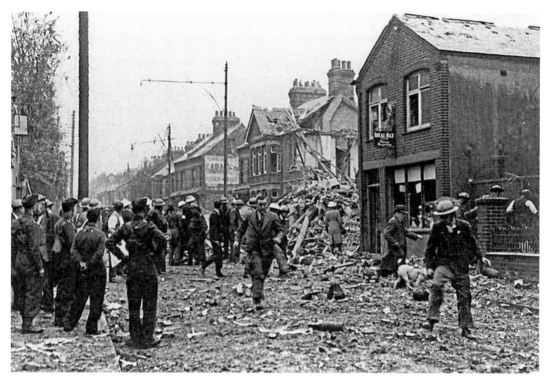

The aftermath of a deadly bomb attack on the Old Bedford Road on 15 October 1940. (*Luton News*)

get to the Kingdom Hall by Mussons Path. Here, fifteen minutes after the sirens sounded, a German bomb fell on the Scales & Co. and Gregory's hat factories that occupied this site – nineteen people, mostly female employees from the two companies, were killed and over thirty were injured.

Continue up the Old Bedford Road until you reach No. 90, the old Clegg & Holden printing works. Here in the 1970s a famous Luton ghost known as 'Old Cleggie' was often seen. Carry on up the hill and continue past the junction with Cromwell Hill. As you approach Popes Meadow you will pass the site of the old Lyes straw plait dye works, now occupied by the Earls Mead and Knights Field estates. Popes Meadow itself has been a favourite leisure site for many years. In May 1943, the town held Wings for Victory Week, which raised £1.4 million towards the local economy – several training aircraft together with a crashed Stuka dive bomber were exhibited on the Meadow.

Carry on along the Old Bedford Road to Wardown Crescent. Two bombs came down close to where you are now – one at the back of No. 13 Wardown Crescent and the other by East Lodge in Wardown Park – during another air raid on 20 September 1940. Just below the bowling green adjacent to the Old Bedford Road are the raised mounds that mark the cut and cover air-raid shelters used during the Luton Blitz.

Enter the park by the East Lodge Gate. You can check out the museum where the ghostly 'housekeeper' has been seen for many years. After that make your way back towards the

An aerial view of Popes Meadow and the Old Bedford Road, showing the former Lyes straw plait dye works. (Old Photos of Luton FB Group)

playground and follow the long straight Wardown Avenue, also known as Lovers Walk, down to the New Bedford Road. The fountain in the lake on your right was created in 1989 by the parents of Arun Sinha as a memorial to their son.

Make your way back down the New Bedford Road towards the town centre. The modern flats on the left past the junction with Cromwell Hill have been built on the sites of several grand Victorian villas and you will pass their original entrance gates crossing over the River Lea next to the pavement. The Leaside Hotel on the left opposite The Moor is the former home of five-times Mayor of Luton Asher Hucklesby. Continue under the railway bridge and down the New Bedford Road. You'll pass Cresta House on the

Above: Wings for Victory
Week at Popes Meadow
in May 1943. (Old Photos
of Luton FB group)

Left: Wardown Avenue,
also known as Lovers
Walk. (Old Photos of
Luton FB group)

The junction of Alma Street and the Old Bedford Road in 1905. (Ben O'Dell)

right, the site of the old Alma Theatre. The former Co-op, now the Galaxy, was on the left. As you return to St George's Square running into Manchester Street, where now stands the JD Wetherspoon White House, was another pub, the Crown and Anchor, demolished in 1975.

Hats and Horrors – Guided Walk

Our second walk stays in the town centre and looks at the sites of Luton's industrial past. The first part passes through the Platers Lea Conservation Area. As before, it starts in St George's Square and is just over a mile in length. Again walk northwards towards the railway station but this time turn right when you get to Guildford Street. You will soon pass the grand Balfour Hat factory building on the left at No. 50.

Carry on along Guildford Street and cross into the pedestrianised section. This is the land of former hat factories and many of the old buildings survive. On the left at No. 40 is another Balfour factory, constructed in 1905. Continue until you get to the junction with Cheapside. On the left are two big hat factory buildings – No. 32, the old Hubbard straw plait works and warehouse from 1910, and No. 30, built in 1919.

Walk down Cheapside towards the Arndale shopping centre, or The Mall as we have to call it today. The road has changed dramatically in the post-war years. As you walk level with No. 50 you are crossing the River Lea, which flows in an underground culvert at this point below the road. The impressively gabled building just further down on the right at

Looking down Cheapside towards George Street – now part of the Arndale shopping centre. (Old Photos of Luton FB group)

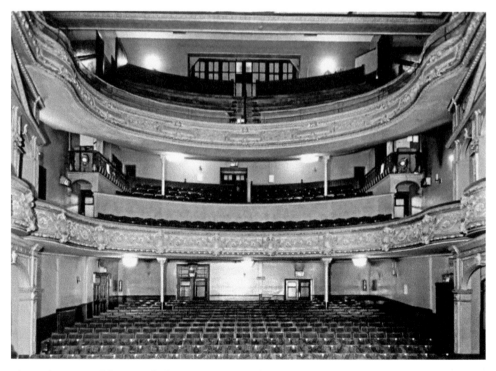

The auditorium of the Grand Theatre, now part of WHSmiths and Tesco. (Old Photos of Luton FB group)

No. 53 is the former Cowper Arms, which was built (in the Queen Anne revival style) as a temperance hotel and coffee house in 1882.

Continue down Cheapside and enter the Arndale by the pedestrian door next to the car park ramp. If you need to do some shopping now is the time. The mall, which crosses from left to right, is the former Waller Street. The Grand Theatre, opened by Lillie Langtry, is now WHSmiths and Tesco. Carry on south along the line of what was Cheapside. There were plait halls on your left and the old post office on your right.

Cross George Street and go down Chapel Steet. This is another road that has changed dramatically. Near the junction with Stuart Street on the left is the Wesley House office block, which is on the site of the former Wesleyan Chapel. Continue on under the Chapel Viaduct and turn right into Regent Street. The car park on the left was at one time the Hubbard dye works. Stop by the pedestrian entrance to the car park and look across at the small service road under the dual carriageway. The parking spaces on the left-hand corner are the location of the house where 'Bertie' Manton committed the Luton Sack Murder in 1943.

Carry on up Regent Street. At the top, the former BBC Three Counties building is said to be haunted by the apparition of a mysterious woman. Use the underpass to cross the main road and make your way back to St George's Square. If you go back via Dunstable Place you will pass the open car park on the corner which used to be the Court House and police station. Carry on down Gordon Street past the old Ritz Cinema where the Beatles played and P. J. Proby caused outrage with his splitting trousers. Back in St George's Square our tour and look at the work of *Secret Luton* has come to an end. I hope you have found it of interest.

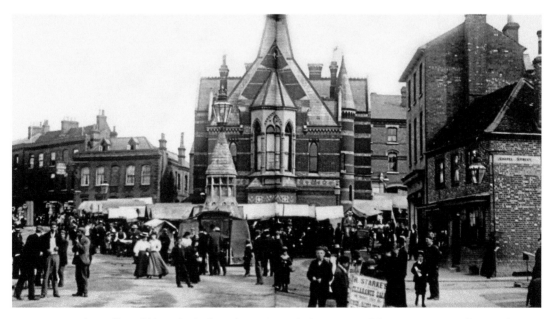

How Market Hill would have looked on a busy day at the beginning of the 1900s as you walk towards Chapel Street. (Old Photos of Luton FB group)

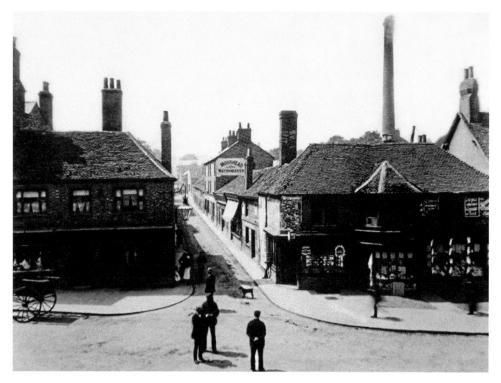

The corner of Chapel Street in 1894. (Old Photos of Luton FB group)

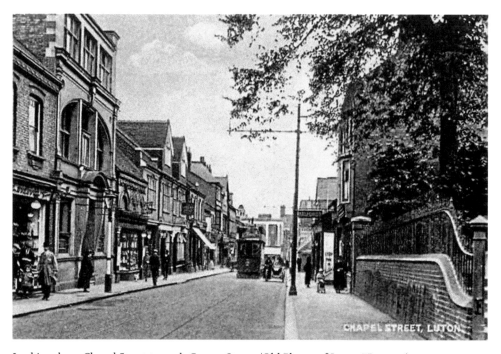

Looking down Chapel Street towards George Street. (Old Photos of Luton FB group)

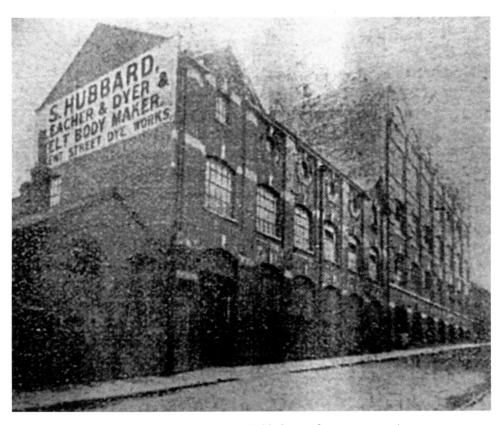

The former Hubbard dye works in Regent Street. (Old Photos of Luton FB group)

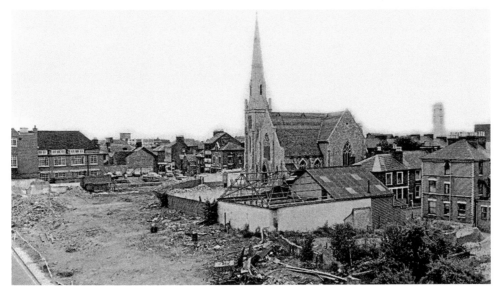

Looking across at what would become the Chapel Viaduct dual carriageway. The Luton Sack Murder house occupied the space at the bottom of the photograph. (*Luton News*)

Further Reading

Adams, Paul, *Haunted Luton & Dunstable* (Stroud: The History Press, 2012)

Allsopp, Anne, *A History of Luton from Conquerors to Carnival* (Andover: Phillimore, 2010)

Austin, William, *A History of Luton and its Hamlets (Two Volumes)* (Newport: The County Press, 1928)

Broughall, Tony and Paul Adams, *Two Haunted Counties* (Luton: Limbury Press, 2010)

Bunker, Stephen, Holgate, Robin & Nichols, Marian, *The Changing Face of Luton* (Dunstable: The Book Castle, 1993)

Craddock, Dave, *Where they Burnt the Town Hall Down* (Dunstable: The Book Castle, 1999)

Dyer, James, Stygall, Frank & Dony, John, *The Story of Luton* (Luton: White Crescent Press Ltd, 1964)

Grabham, Eddie, *From Grand to Grove: Entertaining South Bedfordshire* (Dunstable: The Book Castle, 2007)

Heslop, Paul, *Bedfordshire Casebook: A Reinvestigation into Crimes and Murders* (Dunstable: The Book Castle, 2004)

Kinsey, Wayne, *Hammer Films – The Unsung Heroes* (Sheffield: Tomahawk Press, 2010)

Kinsey, Wayne & Gordon Thomson, *Hammer Films On Location* (Barnby: Peveril Publishing, 2012)

Luton News, *Luton at War (Two Volumes)* (Dunstable: The Book Castle, 2000 & 2001 – originally published by Home Counties Newspapers Ltd, 1947)

Norman, Bob, *Were You Being Served? : Remembering 50 Luton Shops of Yesteryear* (Dunstable: The Book Castle, 2002)

Simpson, Keith, *Forty Years of Murder* (London: Harrap, 1978)

Smith, Stuart, *Pubs and Pints: The Story of Luton's Public Houses and Breweries* (Dunstable: The Book Castle, 1995)